KU-304-916

LIVERPOOL POLYTECHNIC LIBRARY

3 1111 00220 5787
MUSEUM OF MODERN ART , NEW YORK
MODERN GERMAN PAINTING AND SCULPTURE: EX
H EX 709.43 MUS 1931

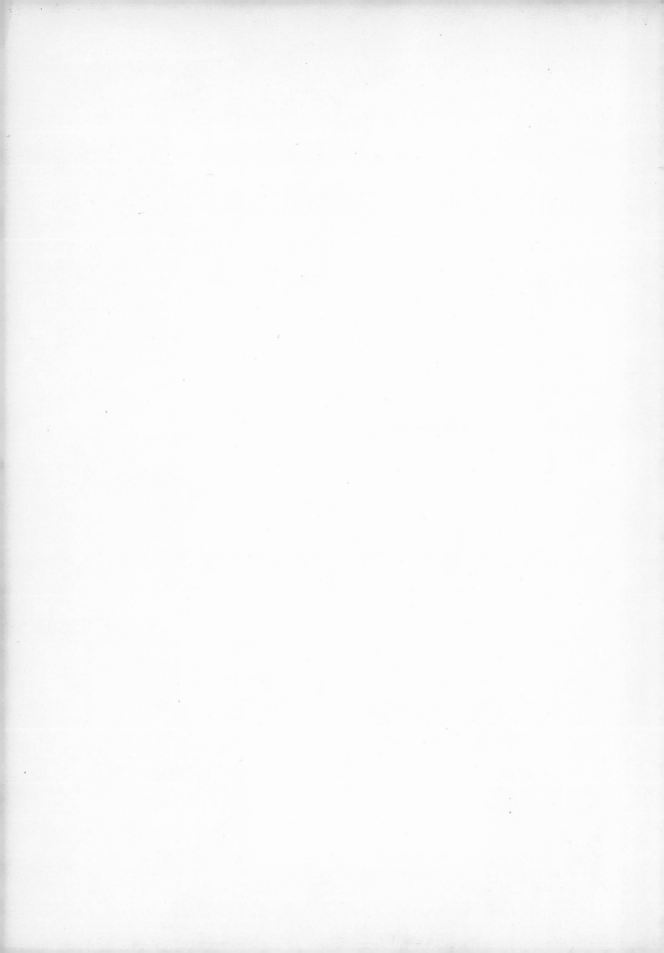

MODERN GERMAN PAINTING AND SCULPTURE

INTRODUCTION AND NOTES

BY ALFRED H. BARR, JR.

MUSEUM OF MODERN ART

Reprint Edition 1972 Published for The Museum of Modern Art by Arno Press

Library of Congress Catalog Card Number 76-169296
ISBN 0-405-01556-9
Printed in the United States of America

THE EXHIBITION HAS BEEN SELECTED FROM THE FOLLOWING COLLECTIONS:

FRAU MATILDA BECKMANN, FRANKFORT-ON-MAIN

MR. RALPH BOOTH, DETROIT

MR. AND MRS. ERICH COHN, NEW YORK

MISS KATHERINE DREIER, NEW YORK

THE FLECHTHEIM GALLERY, BERLIN

HERR CLAUS GEBHARDT, ELBERFELD

DR. F. H. HIRSCHLAND, NEW YORK

THE KESTNER GESELLSCHAFT, HANOVER

DR. AND MRS. EUGENE KLEIN, NEW YORK

HERR BERNARD KOEHLER, BERLIN

PRINCESS MECHTILDE LICHNOWSKY, BERLIN

MR. J. B. NEUMANN, NEW YORK

HERR CARL NIERENDORF, BERLIN

DR. OPPENHEIM, BERLIN

DR. HERMANN POST, NEW YORK

THE REINHARDT GALLERIES, NEW YORK

MRS. JOHN D. ROCKEFELLER, JR., NEW YORK

MR. JOSEF VON STERNBERG, HOLLYWOOD

DR. W. R. VALENTINER, DETROIT

MR. E. M. M. WARBURG, NEW YORK

THE WEYHE GALLERY, NEW YORK

THE NATIONAL GALLERY, BERLIN

THE SILESIAN MUSEUM OF PICTORIAL ARTS, BRESLAU

THE WALLRAF-RICHARTZ MUSEUM, COLOGNE

THE DETROIT INSTITUTE OF ARTS, DETROIT

THE FOLKWANG MUSEUM, ESSEN

THE ART GALLERY, HAMBURG

THE ART GALLERY, MANNHEIM

THE MUNICIPAL MUSEUM, MUNICH

In addition to the individuals and institutions that have lent works of art the Trustees and the Staff wish to thank the following for their co-operation in assembling the exhibition.

Dr. Johannes Sievers, of the Ministry of Foreign Affairs, Berlin; Acting Consul General, Dr. G. Heuser, Consul Dr. Paul Schwarz, and Dr. W. Becker, of the German Consulate, New York.

Director Dr. Ernst Buchner of the Wallraf-Richartz Museum, Cologne.

Director Ernst Gosebruch of the Folkwang Museum, Essen, which in one year has lent the Museum of Modern Art its most important French painting, the *Ecce Homo* by Daumier, and its most important German painting, the *Red Horses* by Franz Marc.

Director Dr. Gustav Hartlaub of the Mannheim Art Gallery.

Director Dr. Ludwig Justi and Dr. Ludwig Thormaehlen of the National Gallery, Berlin.

Director Dr. Gustav Pauli of the Hamburg Art Gallery. ·

Director Dr. Alois Schardt of the Municipal Museum, Halle.

Director Dr. W. R. Valentiner and Dr. Walter Heil of the Detroit Institute of Arts.

Director Dr. Erich Wiese of the Silesian Museum of the Pictorial Arts, Breslau.

Herr Alfred Flechtheim, Berlin; Herr Günther Franke, Munich; Mr. J. B. Neumann, New York; Herr Rudolf Probst, Dresden; Mr. E. Weyhe, New York; Mr. Carl Zigrosser, New York.

Herr Flechtheim, Mr. Neumann, and Herr Valentin for special assistance in preparing data for catalog.

The North German Lloyd, Bremen, for their courtesy in giving ocean transport at reduced rates.

TRUSTEES

A. CONGER GOODYEAR, *President*

MISS L. P. BLISS, *Vice-President*

MRS. JOHN D. ROCKEFELLER, JR., *Treasurer*

SAMUEL A. LEWISOHN, *Secretary*

WILLIAM T. ALDRICH

JAMES W. BARNEY

FREDERIC C. BARTLETT

STEPHEN C. CLARK

MRS. W. MURRAY CRANE

FRANK CROWNINSHIELD

CHESTER DALE

DUNCAN PHILLIPS

MRS. RAINEY ROGERS

MRS. CHARLES C. RUMSEY

ARTHUR SACHS

PAUL J. SACHS

JOHN T. SPAULDING

MRS. CORNELIUS J. SULLIVAN

JOHN HAY WHITNEY

ALFRED H. BARR, JR.
Director

JERE ABBOTT
Associate Director

INTRODUCTION

In matters of art Germany, France, England, Italy, America and other countries assume the paradoxical position of standing with their backs toward one another and their faces toward Paris. During the late nineteenth century as many American artists studied in Germany as in Paris but more recently and especially during and since the War, America and Germany have been more or less isolated from one another so far as painting and sculpture are concerned. Largely through American inertia few of our best modern artists have been exhibited in Germany. On the other hand, it is mainly through American initiative that some modern German art has already been shown in America, though for the most part not in New York. The German sections of the Pittsburg International Exhibition have recently been very well chosen. An excellent collection of modern German paintings is on view in the Detroit Museum. Among the most important European sculptors the German, Wilhelm Lehmbruck, received much attention at the famous Armory Exhibition held in New York in 1913. In 1923, perhaps too shortly after the War, an exhibition of German art was organized by Dr. Valentiner at the Anderson Galleries. Several good German painters were also included in the Tri-national Exhibition, and many of the best left wing painters have been introduced to New York through the courageous Société Anonyme. Adventurous dealers have also shown the work of contemporary Germans from time to time.

To appreciate German art it is necessary to realize that much of it is very different from either French or American art. Most German artists are romantic, they seem to be less interested in form and style as ends in themselves and more in feeling, in emotional values and even in moral, religious, social and philosophical considerations. German art is as a rule not pure art. Dürer was interested in the world of fact, science and metaphysics, Holbein was interested in the analysis of human character, Grünewald in violent sensation and emotion. Many contemporary German artists follow in their footsteps. It is significant that German painters do not concern themselves over much with still-life, *nature morte*, and that German sculptors are usually not satisfied with torsos. They frequently confuse art and life.

However much modern German art is admired or misunderstood abroad, it is certainly supported publicly and privately in Germany with extraordinary generosity. Museum directors have the courage, foresight and knowledge to buy

GERMAN ART

MODERN ART
IN GERMAN
MUSEUMS

works by the most advanced artists long before public opinion forces them to do so. Some fifty German Museums, as the lists in this catalog suggest, are a most positive factor both in supporting artists and in educating the public to an understanding of their work.

IN PUB-
LICATIONS
German scholars, curators, critics and publishers are as active as the Museums. Almost every German artist of any importance has at least one monograph on his work written by a reputable authority and handsomely—or what is even better—cheaply published. Many painters have four or five books on various aspects of their art. There is, for instance, a small inexpensive volume on Kirchner's work as a whole, another and sumptuous volume on his paintings, another on his drawings and a fourth on his etchings and woodcuts, not to mention many articles in periodicals. There is an active market for such books. Large and carefully executed reproductions of modern paintings are also sold in quantities.

IN ART
SCHOOLS
German art schools, academies, schools of applied arts, are remarkable in that they employ as teachers many of the most advanced German sculptors and painters. The present exhibition includes many of the foremost artists of contemporary Germany. Almost all of these men have been condemned at some time during their lives as "radical" and some of them are still in the advance guard. Yet in spite of the unacademic character of their work about half of them are Professors in municipal art schools. Hofer, Kolbe, and de Fiori teach in Berlin, Baumeister and Beckmann in Frankfort, Campendonk in Krefeld, Klee at the Bauhaus, Otto Dix in the Dresden Academy, Kokoschka (until recently) in Dresden, Molzahn at Magdeburg and now in Breslau, Marcks in Halle, Otto Mueller (until his recent death) in Breslau, Rohlfs at Hagen, and Schlemmer formerly in Dessau and now also in Breslau. Through employing creative artists, the German art academies keep abreast of the times without sacrificing discipline, for the Germans, like most good modern artists, have had a thorough training in the technique of their art.

A very important by-product of these academic positions is the economic security and leisure which sometimes—romantic tradition to the contrary—permits many of the best German artists to work under the most favorable conditions.

SCOPE OF
EXHIBITION
The present exhibition makes no pretense of including all the important living German artists nor even all the movements or groups which have produced good painting or sculpture. In spite of their fame the impressionist trio of Max Liebermann, Lovis Corinth and Max Slevogt are omitted since they belong to a

generation and school which has had little sympathy with the work of most living artists. Another trio, Purrmann, Moll and Levy, excellent painters as they are, have been too much under the domination of Matisse to make the exhibition of their work valuable. Another group, the painters of abstract composition, are essentially international: Kandinsky is Russian, Moholy-Nagy is Hungarian. Their work, together with that of Schwitters and Bauer, would be more appropriately shown together with their Dutch, Russian and French co-workers. Lyonel Feininger, the German-American whose style is unique among those painting in Germany has already been shown by the Museum. Max Ernst, Hans Arp and Dietz Edzard have identified themselves with the school of Paris.

The exhibition begins with the period which may be called for the sake of convenience *expressionist* and which extends in Germany from about 1905 till after the War, together with the last ten years which for the want of a better label have been termed *post-expressionist*.

Expressionism has several connotations; it was first used in Munich by the members of the Blue Rider group about 1911 as a battle cry of those who opposed *impressionism*. The impressionists, such as the Frenchman, Monet, or the German, Liebermann, painted, theoretically at least, the momentary impression of the outside world without interposing the imagination, the intellect, the emotions and without much care for composition. The expressionist in contrast looked within, not out, for inspiration, and often for subject matter, depending more upon his inner eye, because he wished to create a new vision rather than to record the familiar world; his art is more personal and therefor more difficult to understand without some tolerance and sympathy on the part of those unaccustomed to his attitude. Impressionism implies subservience to nature; expressionism implies subservience to the human imagination.

Expressionism developed in modern German art about thirty years ago from two general sources, primitive art and the art of several foreign painters, the Dutchman, van Gogh, the Frenchmen, Cézanne and Gauguin, the Swiss, Ferdinand Hodler, and the Norwegian, Edvard Munch. Of these van Gogh and Munch were the most important. Neither of them were Latin though both were familiar with French art of the late nineteenth century. Van Gogh's fiery color patterns and tortured drawing, his evangelical passion for humanity and the tragedy of his life and death are known wherever modern painting is appreciated. Munch's fame is more narrowly confined to Scandinavia and Germany.

His art is as deeply felt as van Gogh's but is silent with a northern melancholy conveyed by simplified drawing and color and by sparse composition.

THE *BRÜCKE* The first group of German expressionists was formed in Dresden about 1905 by three young students: Kirchner, Schmidt-Rottluff and Heckel who called themselves *Die Brücke*—The Bridge. They were joined a year later by Pechtstein and the already mature Emil Nolde, and in 1910 by Otto Mueller. They were almost exactly contemporary with the Parisian *Fauve* group of which Matisse and Derain were the leaders.

Although the Parisian and Dresden groups developed independently they had common sources both in their admiration for Gauguin and van Gogh and in their enthusiasm for primitive art. Although it is useless to quibble over chronology it seems probable that Kirchner's discovery of African and Polynesian art in the Dresden Ethnological Museum in 1904 definitely precedes Vlaminck's discovery of negro sculpture in Paris. What is more important is the fact that as soon as they had come upon primitive art the Germans did not turn it into a formal exercise such as cubism. Kirchner, Schmidt-Rottluff, Barlach and later Klee, Campendonk and Beckmann admired the form of primitive art but they also studied its spirit. The Germans also turned to medieval art as well as to exotic, finding in Gothic woodcuts and Romanesque sculpture sanction for an art of expression as opposed to an art of imitation.

Inspired perhaps by a romantic interpretation of medieval guilds the *Brücke* in its beginnings kept to an amazingly idealistic program. They lived and painted together, sharing studio, paints, brushes and models. They even exhibited together without signing their canvases. Later, individualism triumphed and the group was formally dissolved in 1913.

Their paintings until after 1920 had much in common; all used more or less "unnatural" color, frequently in a bold, decorative pattern. They drew with a heavy, usually angular outline. Their work shocked contemporary Germany but it now seems definitely to belong to the older generation. During the last ten years Nolde's style has remained unchanged. Kirchner paints more in an abstract style. Heckel, Schmidt-Rottluff and Pechstein compromise more with realism. At their worst the paintings of the *Brücke* are magnificent posters, at their best they are among the finest paintings of the expressionist period.

THE BLUE RIDER Very different in spirit and style was the second German expressionist group, the famous *Blaue Reiter*, or Blue Rider, which was organized in Munich in 1911 by Franz Marc and Kandinsky, joined by August Macke, Paul Klee and Cam-

pendonk. They were less naïve, more belligerent and more doctrinaire than the men of the *Brücke*. Von Tschudi, the most enlightened museum director of the time in Europe, had purchased paintings by Cézanne, van Gogh and Gauguin for the Munich Neue Pinakothek which was much frequented by the young rebels. They were also familiar with the current activities in Paris. They published in 1912 an elaborate manifesto, dedicated to von Tschudi, in which they declared their principles and enthusiasms. In it we find illustrated, in addition to their own work, Coptic textiles, Egyptian puppets, Bavarian peasant glass paintings, Byzantine mosaics, Gothic sculpture, early woodcuts, German primitives, and paintings by El Greco, Cézanne, Henri Rousseau, Picasso. They exhibited in Munich, Berlin and Cologne, arousing far greater controversy than the *Brücke*.

Kandinsky's art developed into complete abstraction in which any resemblance to natural objects was lost. Klee experimented in a minor key with fantastic inventions. Macke painted figures in landscapes with bold, flat color. Campendonk, a visitor from the Lower Rhine, found stimulus in peasant art. Marc possibly the finest artist of the group painted brilliantly decorative compositions using animals as motives. The War shattered the *Blaue Reiter*. Kandinsky returned to Russia though he later rejoined Klee after the War at the Bauhaus in Weimar, but Macke and Marc were both killed before their rich promise came to full maturity.

Several of the most important painters of the expressionist generation did not ally themselves with any group. Paula Modersohn of Bremen was, at the time of her early death, in 1907, one of the most advanced artists in Germany in her personal interpretation of the tradition of Cézanne and Gauguin. Kleinschmidt in Berlin, exhibiting with the Berlin Secession, gave evidence in his work of his study of Corinth, van Gogh. Christian Rohlfs at the age of eighty still retains his fame as one of the earliest expressionists of the lower Rhine.

Internationally one of the best known among German expressionists is the Austrian Kokoschka. Trained in Vienna, the feverish intensity of his early work was first appreciated in Dresden and Berlin and later in Paris where such painters as Soutine have followed in his footsteps. Whether Kokoschka's later, more objective style equals the importance of his early work is still a matter of argument.

Karl Hofer is by temperament classical rather than expressionist. More than any other German painter of importance he has been influenced by the French tradition of Cézanne and Derain. His distinguished color and powerful sense of

form make him one of the most imposing though not one of the most original of modern Germans.

BECKMANN Max Beckmann emerged from the vigorous impressionism of the first Berlin Secession, passed through the war period with a violent, contorted manner suggestive of German primitives, into his present style which for strength, vitality and breadth of feeling is unequalled in Germany. Whether the genuine greatness of his personality will be realized in his paintings so that he will take his place among the half dozen foremost modern artists is a question which the next few years should answer.

POST-EXPRES-SIONISM Since the War expressionism has been followed by various reactions even in the work of leaders in the movement. Several members of the *Brücke* for instance now paint with more consideration for natural appearances. Kokoschka has turned practically impressionist. Beckmann's work has become happier in spirit and more disciplined in form. But there are also at least three distinguishable movements on the part of younger artists in the repudiation of expressionism. One of these, which is not illustrated in the present exhibition, has taken the form of abstract composition of more or less geometrical shapes. Another and very wide-spread movement concerns itself with emphatic and frequently exact realistic painting of the objective world. It has been called *die Neue Sachlich-keit*—the New Objectivity. A third which we may call the Architectonic movement is intellectual, constructive, and objective, semi-abstract in form and related in feeling to recent architecture.

ARCHITEC-TONIC "Architectonic" may be defined as relating to or displaying the quality or nature of architecture. The term may serve as a convenient designation for three artists who are in no sense a group except in that the purpose and principles of their work are similar. Baumeister and Schlemmer, whose names are frequently linked, were students together in Stuttgart. Molzahn developed independently. All three men are versatile in the extreme. Molzahn is master of typography as well as of painting; Baumeister of interior architecture; Schlemmer is a re-markable innovator in the modern theater and ballet. In their paintings all three men use the human figure in highly conventionalized often quasi-geometric style. All three think of their paintings as related to architectural surfaces and have experimented accordingly with a variety of surface treatment and even of semi-abstract colored wall reliefs. The architectonic group is allied to the similar Parisian circle of which Léger and Ozenfant are leaders, and to the Milanese group of the *Valori Plastici*. The leaders of the new international style of archi-

tecture—Corbusier, Mies van der Rohe, Gropius, and Oud—have appropriately used the services of these architectonic painters.

The phase "New Objectivity"* was invented by Dr. G. F. Hartlaub, Director of the Mannheim Kunsthalle to designate artists who were turning both from expressionism and from abstract design to concentrate upon the objective, material world. The movement is strongest in Germany but has adherents in other countries—Herbin, Pierre Roy, Picasso at times, Severini, Ivan Baby, and others in Paris; the *novecentisti* in Italy; in England, Wadsworth, Richard Wyndham, and Laura Knight; in America, Charles Sheeler, James Chapin, Edward Hopper, Stefan Hirsch, and Katherine Schmidt. Almost all these painters have passed through at one time or another a period of abstract or expressionist experiment. Similarly in Germany, the three men who are chosen to represent the New Objectivity in the present exhibition have each of them experienced the discipline of abstract composition and the license of expressionism. George Grosz's most important work is in drawing and watercolor by which he has made himself a scourge to all that is comfortable and vulgar in contemporary Germany. Otto Dix, less brilliant than Grosz, but stronger, paints with a strident at times almost bizarre realism. Georg Schrimpf is as mild as the other two are assertive. In the work of these men may be found resemblances to 15th century painters such as Crivelli or Perugino, to choose a pair of opposites, or, in the north to the greatest of German painters, Dürer, Holbein, or Grünewald. Certain German painters of the early 19th century, such as Schadow, Runge and V. I. Janssen, are also among their sources. The New Objectivity is no longer new and like expressionism is taking its place in the past. The future of German painting is difficult to discern. No movement at present is dominant in Germany any more than it is in Paris or America.

German sculpture is on the whole better known outside of Germany than is German painting. Lehmbruck, Kolbe, and Ernesto de Fiori have long been figures of international importance. Lehmbruck whose work was included in the Museum's special exhibition of last year is dead. Kolbe and de Fiori with the

* A letter written by Doctor Hartlaub and published in *The Arts* of January, 1931, is worth quoting: "The expression *Neue Sachlichkeit* was in fact coined by me in the year 1924. A year later came the Mannheim exhibition which bore the same name. The expression ought really to apply as a label to the new realism bearing a socialistic flavor. It was related to the general contemporary feeling in Germany of resignation and cynicism after a period of exuberant hopes (which had found an outlet in expressionism). Cynicism and resignation are the negative side of the *Neue Sachlichkeit;* the positive side expresses itself in the enthusiasm for the immediate reality as a result of the desire to take things entirely objectively on a material basis without immediately investing them with ideal implications. This healthy disillusionment finds its clearest expression in Germany in architecture. In the last analysis this battle cry is today much misused and it is high time to withdraw it from currency."

Swiss Hermann Haller may be said to form a group whose work is interesting primarily through the modelling and composition of the single human figure. They have all learned something from Maillol and a little from archaic sculpture, medieval Greek, or Egyptian. Like them Renée Sintenis is primarily a clay modeller. Her work, confined principally to figurines of animals, is essentially and charmingly feminine.

BARLACH Ernst Barlach stands apart. He has little interest either in the refinements of clay modelling and bronze patine or in the problem of inventing variations in composing the female figure. He is primarily a carver of wood inspired by Gothic wood sculptors. Like them, Barlach uses voluminous draperies, expressionist gestures and faces which have more character than sweetness. Barlach is a dynamic force as well as a maker of figures. Related both to Barlach and to the Kolbe-de Fiori group is a younger sculptor of great promise, Gerhard Marcks. BELLING Rudolf Belling is one of the few German sculptors who can be called radically experimental. He can model with academic skill but prefers a bolder program which carries him from caricature to abstract construction.

GERMANY'S POSITION Many believe that German painting is second only to the School of Paris, and that German sculpture is at least equal to that of any other nation. Such convictions are an interesting subject for speculation, but whatever may be the ultimate decision Germany may well be proud of such painters as Beckmann, Dix, Grosz, Hofer, Kirchner, Klee, Marc, and Nolde and of such sculptors as Barlach, de Fiori, and Kolbe.

MODERN ART IN GERMAN MUSEUMS

Most surprising to the student of modern art is the alert attitude of German museums toward modern art. Even in small towns the museums have their figures by Kolbe or Barlach, their paintings by Heckel, Hofer or Beckmann, their watercolors by Klee and Nolde. Larger cities have special galleries devoted to modern art with special catalogs, which list, in the case of Dresden for instance, over 700 19th and 20th century works (exclusive of prints), in the case of Hamburg 1577, and Essen 774. Berlin and Munich have entirely separate institutions devoted to modern art *since* Impressionism. A dozen German museums include work by almost all the artists represented in the present exhibition, while forty more own works by several.

So generous and forethoughtful are German museums that they have become, especially in these times of depression, a very important economic factor in supporting German artists through purchase of their works—especially in the cases of those artists who have no municipal teaching positions and no independent income.

The following list comprises *over fifty* German museums which own work by one or more (usually many) of the artists included in the present exhibition. Throughout the remainder of the catalog these museums are referred to by the name of the city only, except when there is in the city more than one museum containing modern art.

AACHEN	Municipal Suermondt Museum
AUGSBURG	Municipal Museum
BARMEN	Ruhmeshalle
BERLIN	National Gallery, Crown Prince's Palace
BIELEFELD	Municipal Museum of Fine and Applied Arts
BREMEN	Art Gallery
BREMEN	Modersohn-Becker Museum
BRESLAU	Silesian Museum of Pictorial Arts
BRUNSWICK	Municipal Museum
CASSEL	Municipal Gallery
CHEMNITZ	Municipal Art Collection
COLOGNE	Wallraf-Richartz Museum
DANZIG	Municipal Museum
DARMSTADT	Hessian State Museum
DORTMUND	Municipal Museum

DRESDEN	Modern Gallery (wing of the State Picture Gallery)
DRESDEN	Albertinum (sculpture museum)
DÜSSELDORF	Municipal Art Museum
DUISBURG	Municipal Museum
ELBERFELD	Municipal Museum
ERFURT	Municipal Museum
ESSEN	Folkwang Museum
FRANKFORT ON THE MAIN	Municipal Gallery
FREIBURG	Art Gallery
GELZENKIRCHEN	Art Gallery
HAGEN	Christian Rohlfs Museum
HALLE	Municipal Museum of Fine and Applied Art
HAMBURG	Art Gallery
HAMBURG	Museum of Fine and Applied Art
HANOVER	Provincial Museum
JENA	Municipal Museum
KARLSRUHE	Art Gallery
KONIGSBERG	Municipal Art Collection
KREFELD	Kaiser Wilhelm Museum
LEIPZIG	Museum of the Pictorial Arts
LÜBECK	Museum of Art and Cultural History
MAGDEBURG	Kaiser Friedrich Museum
MANNHEIM	Art Gallery
MARBURG	Art Historical Collection
MÜHLHEIM	Municipal Museum
MÜNSTER	Municipal Museum
MUNICH	New State Gallery
MUNICH	Municipal Gallery
MUNICH-GLADBACH (Rhineland)	Municipal Museum
NUREMBERG	Municipal Art Collection
OLDENBURG	Municipal Museum
OSNABRÜCK	Municipal Museum
PFORZHEIM	Reuchlin Museum
SAARBRÜCKEN	Municipal Museum
STETTIN	Municipal Museum
ULM	Municipal Museum
WEIMAR	State Art Gallery
WIESBADEN	Municipal Picture Gallery

CATALOG

PAINTERS

NOTE: An asterisk before a catalog number indicates that the painting is illustrated by a plate which bears the same number.

WILLY BAUMEISTER

*1 ATHLETIC FIELD (1930)
Collection the Flechtheim Gallery, Berlin

2 MAN IN A TENT (1930)
Collection the Flechtheim Gallery, Berlin

Willy Baumeister. Born in Stuttgart, 1889. With his friend Schlemmer studied in the Stuttgart Art School under Adolf Hölzel, one of the first teachers in Germany to point to Cézanne as an inspiration for students. Exhibited at the Sturm Gallery in 1913. Now an instructor in the Frankfort Academy.

Shortly before 1920 Baumeister began to search for a method of making his painting an integral part of the room. He considered the whole room—walls, ceiling and floor—as a problem in color composition which might be epitomized by a painting or colored plaster relief. His exhibition in Paris in 1927 excited much interest and brought him into contact with Léger, Ozenfant, and Jeanneret. After considerable interchange of ideas Baumeister left Paris taking with him certain elements of Léger's style but leaving to Ozenfant principles of mural design which he and other lesser Parisians were to develop.

Athletic Field (No. 1) and *Man in a Tent* (No. 2) represent Baumeister's latest style. They are studies for mural paintings in which decorative geometry and realistic representation of objects meet halfway. They should be compared with the somewhat similar experiments of Schlemmer (Nos. 80, 81) and Molzahn (Nos. 63, 64).

Beaumeister is represented in the museums of five cities: Essen, Frankfort on the Main, Hanover, Karlsruhe, and Mannheim.

MAX BECKMANN

3 THE PRODIGAL SON AMONG SWINE (1921), *gouache*
Collection the Folkwang Museum, *Essen*

4 THE PRODIGAL SON AMONG COURTESANS (1921), *gouache*
Collection the Folkwang Museum, Essen

5 FAMILY PICTURE (1922)
Collection Kestner-Gesellschaft, Hanover, (courtesy J. B. Neumann-Günther Franke, Munich)

6 OLD ACTRESS (1923)
Private Collection, New York

*7 SELF PORTRAIT WITH A CIGAR (1923)
Collection Dr. F. H. Hirschland, New York

*8 BALLOON ACROBATS (1925)
Collection Claus Gebhardt, Elberfeld (courtesy J. B. Neumann-Günther Franke, Munich)

*9 THE LOGE (1928)
Collection Dr. Oppenheim, Berlin

10 CARNIVAL (1929)
Collection Frau Matilda Beckmann, Frankfort

Max Beckmann. Born in Leipzig, 1884. Studied at the Weimar Academy, 1900-03. Traveled to Italy on a scholarship, 1904. Joined the Berlin Secession, 1906. Lived at Hermsdorf near Berlin, 1906-14; the war, 1914-17. Since 1917 has lived in Frankfort teaching at the Academy. Second prize Carnegie Exhibition, Pittsburgh, 1929, (*The Loge*, No. 9). During the last two years has spent much time in Paris.

Max Beckmann developed rapidly after his early academic successes. At the age of twenty-five he had become the *enfant terrible* of the first Berlin Secession which was dominated by a powerful Impressionist group led by Max Liebermann. By 1912 perhaps under the influence of Edvard Munch he had begun to simplify his style. During the anguish and strain of the war he developed expressionist tendencies to an almost pathological degree. Certain paintings of this period are veritable nightmares of a tortured spirit. But during the last ten years his art has recovered stability and has increased in power.

Beckmann's post-war style owes much (as is apparent in the *Prodigal Son* series of 1921—Nos. 3 and 4) to the drawing and composition of 15th century woodcuts. In the *Family Picture* (No. 5) of 1922 there is still the tendency to compress his composition into a kind of sculptural relief of angular forms. Few of his works are finer in color. The directness and occasional grimness of his work is apparent in the portraits of an *Old Actress* (No. 6) and in the *Self Portrait with a Cigar* (No. 7) both of 1923. In them we discover a merciless study of character sometimes with a slight inclination toward the grotesque, a tendency magnificently realized in the *Balloon Acrobats* (No. 8) and the *Carnival* (No. 10). *The Loge* (No. 9) of 1928 has been much admired especially in America but seems by comparison slightly superficial.

Beckmann's originality of invention, his power in realizing his ideas, his fresh strong color, and the formidable weight of his personality, make him one of the most important living European artists.

Beckmann is represented by paintings in the museums of seventeen cities: Barmen, Basel, Berlin, Bremen, Cologne, Detroit (Institute of Arts), Dresden, Düsseldorf, Essen, Frankfort on the Main, Halle, Mannheim, Munich, Stettin, Stuttgart, Weimar, and Zürich (Art Museum).

HEINRICH CAMPENDONK

*11 THE WHITE TREE (1925)
 Collection Miss Katherine Dreier, New York

12 THE RED CAT (1926)
 Collection Miss Katherine Dreier, New York

Heinrich Campendonk. Born at Krefeld, 1889. Studied under the Dutch painter Thorn-Prikker, through whom he learned to appreciate the work of Giotto, Fra Angelico, van Gogh, and Cézanne. Later became acquainted with Kandinsky and Franz Marc with whom he exhibited in the first exhibition of the Blue Rider, Munich 1912. Italy in 1920; Giotto, the Ravenna mosaics. Now a professor at the Krefeld Art School.

Campendonk's art developed principally under the influence of Franz Marc and of peasant art, especially votive pictures painted behind glass. Since 1918 he has painted lyrical, often fantastic compositions in which domestic animals, peasants, farm houses, have been used as motives. In their derivation from peasant art and in their atmosphere of folk legend, Campendonk's paintings are analogous to the Russian Chagall's. But Campendonk is less grotesque and less humorous than Chagall and more sensitive. He is possessed rather by a gentle bucolic mysticism.

Campendonk is represented in the museums of six cities: Berlin, Cologne, Düsseldorf, Frankfort on the Main, Krefeld, and Moscow (Museum of Modern Western Art).

OTTO DIX

*13 PORTRAIT OF THE ARTIST'S PARENTS (1921)
 Collection Wallraf-Richartz Museum, Cologne

*14 THE WIDOW (1925)
 Collection the Art Gallery, Mannheim

*15 DR. MEYER-HERMANN (1926)
 Collection the Artist

16 BABY (1928)
 Collection the National Gallery, Berlin

17 CHILD WITH DOLL (1930)
 Collection the Artist

Otto Dix. Born 1891 at Unterhaus near Gera in Saxony. Worked as a mural decorator's assistant, 1905–10. Studied in the School for Arts and Crafts at Dresden and in the Academy 1910–12.

Fought in Flanders and in France, 1914–18. Since the war has lived in Düsseldorf, Berlin, and more recently in Dresden where he is professor in the Academy.

Dix's parents were workers in the Gera mine fields. Their portraits (No. 13) throw light on the background of the painter. Dix's early work was based upon the Italian *quattrocento* but immediately after the war, aghast and disgusted at civilization, he went through a period of bitter *dada* after which, with his companion Grosz, he ruthlessly attacked the stupidity and hypocrisy which he saw about him. In a series of etchings and paintings he also made permanent his grisly memories of the war which have much in common with the work of the novelist Remarque whose "All Quiet on the Western Front" has proven so popular all over the world, in spite of its unflinching realism.

Dix has now left the horrors of war and the disillusion of revolution behind him and has become with Grosz the leader of the movement called "the new objectivity." Mordant realism is apparent in almost all his work but is accompanied by a very keen and original sense of the grotesque. His attitude in *The Widow* (No. 14) is diabolic but becomes more kindly in the extraordinary arrangement of rotundities which he has constructed in painting *Dr. Meyer-Hermann* and his alpine ray machine (No. 15). Even in the paintings of his babies (Nos. 16 and 17) Dix discovers a strange, slightly uncanny feeling.

Dix's art is not merely a reaction to the abstract, cubist or expressionist denial of natural appearances. It is, rather, a deep seated passion for the appearance of the real world which he shares with his artistic ancestors of the early 19th century and his greater forebears of four centuries ago—Dürer, Holbein, and Grünewald.

Dix is represented by paintings in the museums of ten cities: Barmen, Berlin, Cologne, Dresden, Düsseldorf, Essen, Frankfort on the Main, Mannheim, Stuttgart, and Wiesbaden.

GEORGE GROSZ

*18 THE ENGINEER HEARTFIELD (1920), *watercolor and clipping-montage*
 Collection Dr. Hermann Post, New York

*19 DR. NEISSE (1927)
 Collection the Flechtheim Gallery, Berlin

20 POMPE FUNÈBRE (1929)
 Collection the Flechtheim Gallery, Berlin

21 MARKET (*about* 1930), *watercolor*
 Collection the Weyhe Gallery, New York

22 CAFÉ SCENE (*about* 1930), *watercolor*
 Collection the Weyhe Gallery, New York

23 MODEL (1930), *watercolor*
Collection the Fletchtheim Gallery, Berlin

*24 WORKING MAN (1930), *watercolor*
Collection the Flechtheim Gallery, Berlin

George Grosz. Born in Berlin, 1893. Studied at the Dresden Academy, 1909-12. Has lived since the war in Berlin.

George Grosz is frequently considered the most important living satirical draughtsman. Before the war he made drawings, usually of proletarian subjects, for German periodicals especially *Illustration*. During the same period his gift for caricature developed. The war poisoned his spirit as it did that of so many German artists so that he became during the period of revolution and reconstruction a most feared pictorial commentator upon bourgeois society. Even more than Dix he has been in and out of law courts charged with sacrilege, treason, indecency, and all manner of heretical protests against the existing order.

The Engineer Heartfield of 1920 (No. 18) illustrates Grosz's *dada* period with its cynical implications of a mechanized deterministic philosophy. In the *Dr. Neisse* of 1927 (No. 19) a study for the portrait in the Mannheim Art Gallery, Grosz allies himself definitely with the realism of the "new objectivity." The four watercolors illustrate his recent style which is far freer and more painter-like than his earlier work. The humor too is less malicious and concerned more with the ridiculous than with the iconoclastic. Yet even in these as in all his work Grosz suggests that man is for him a none too pleasant animal. He is of the company of Rowlandson, Toulouse-Lautrec and Dean Swift.

Grosz is represented by paintings and drawings in the museums of eighteen cities: Amsterdam (Stedelijk), Barmen, Berlin (Collection of the City of Berlin, and Ministry of the Interior), Breslau, Detroit (Institute of Arts), Dresden, Düsseldorf, Elberfeld, Essen, Frankfort on the Main, Hamburg, Mannheim, Moscow (Museum of Modern Western Art), Nüremberg, Stettin, Ulm, Venice (Museum of Modern Art), and Wiesbaden.

ERICH HECKEL

*25 PORTRAIT STUDY (1918)
Collection the Detroit Institute of Arts, Detroit

*26 CIRCUS (1921)
Collection the Artist

27 NORTH GERMAN LANDSCAPE (1925), *watercolor*
Collection J. B. Neumann, New York

28 HARBOR SCENE (1929)
 Collection the Artist

29 WOMEN BATHING (1929), *watercolor*
 Collection J. B. Neumann, New York

Erich Heckel. Born in Döbeln, 1883. Studied architecture at the technical high school in Dresden 1904. Gave up architecture 1905 to form, with Kirchner and Schmidt-Rottluff, the *Brücke* group of painters. Met Nolde, Pechstein, and Otto Mueller in 1906–11. In 1911 moved to Berlin where he now lives. Breaking up of the *Brücke* group, 1913. The War 1914–18. Since 1919 in Berlin, traveling in the summers.

Erich Heckel, one of the original founders of the *Brücke*, has as a painter little of the strength of either Schmidt-Rottluff or Kirchner, but is more varied, flexible, and sensitive. The *Portrait Study* (No. 25) of 1918 was painted long after his art had matured but it still retains something of the pathos of his early work. The *Circus* (No. 26) of some years later is in a gayer mood. During the last ten years Heckel has practically abandoned his expressionist manner since it no longer corre-sponds to his needs. His best work recently has been perhaps in watercolor, a medium which he uses without formula but with a fine distinction. *Women Bathing* (No. 29) is an epitome of Heckel's art, fresh, sunlit, idyllic.

Heckel is represented by paintings in the museums of thirty cities: Barmen, Berlin (National Gallery), Bremen, Breslau, Chemnitz, Cologne, Danzig, Darmstadt, Dresden, Elberfeld, Erfurt, Essen, Frankfort on the Main, Halle, Hamburg, Hanover, Jena, Kiel, Krefeld, Leipzig, Lübeck, Magdeburg, Mannheim, Munich, Munich-Gladbach, Oldenburg, Osnabrück, Stettin, Vienna, Wiesbaden.

KARL HOFER

30 PORTRAIT OF A. F. (1922)
 Private Collection Alfred Flechtheim, Berlin

*31 MUZZANO (*about* 1925)
 Collection the Wallraf-Richartz Museum, Cologne

*32 NIGHT CLUB (1927)
 Collection the Flechtheim Gallery, Berlin

33 GIRL WITH A CAT (1929)
 Collection the Flechtheim Gallery, Berlin

*34 MELON (1929)
 Collection the Flechtheim Gallery, Berlin

35 MOUNTAIN CHURCH (1930)
 Collection the Flechtheim Gallery, Berlin

36 STILL LIFE WITH CAN (1930)
 Collection the Flechtheim Gallery, Berlin

37 THE YELLOW FLAG (1930)
 Collection the Flechtheim Gallery, Berlin

Karl Hofer. Born at Karlsruhe 1878. Entered Karlsruhe academy. Paris for a year in 1900. Then studied under Hans Thoma but without profit. Rome 1903. Paris during five years before the War. Since 1919, Berlin. Judge at Carnegie Exhibition, Pittsburgh, 1929.

Hofer's early work was done under the influence of Puvis de Chavannes. Later, primitive art interested him as well as the work of Cézanne, Picasso (in his pre-cubistic periods) and Derain. Since the War he has developed a highly individual style, severe, thoughtful and decidedly more classical in feeling than that of any other important contemporary German painter. In all his works one feels careful structure and ability to compose whether it be in portraits such as that of *Alfred Flechtheim* (No. 30), in landscapes such as the *Muzzano* (No. 31) or in large figure-compositions such as the imposing *Night Club* (No. 32). The *Melon* (No. 34) proves his ability to paint beautifully and others of his pictures especially the *Yellow Flag* (No. 37) and the *Muzzano* illustrate what is perhaps his most original quality, his color.

Hofer's reputation outside of Germany is considerable because he has succeeded in doing well what few other Germans are really interested in: composition in the tradition of Cézanne.

Hofer is represented by paintings in the museums of twenty-four cities: Aachen, Basel (Municipal Picture Gallery), Berlin, Bremen, Breslau, Cassel, Chemnitz, Cologne, Detroit, Dresden, Elberfeld, Frankfort on the Main, Hamburg, Karlsruhe, Mannheim, Munich (Municipal Gallery), Prague (Modern Gallery), Rome (National Museum of Modern Art), Saarbrücken, Stuttgart, Vienna (Modern Gallery), Wiesbaden, Winterthur (Museum), Zürich (Art Museum).

ERNST LUDWIG KIRCHNER

*38 STREET SCENE (1913)
 Collection the National Gallery, Berlin

39 RHINE BRIDGE (1914)
 Collection the National Gallery, Berlin

40 MOUNTAIN LANDSCAPE (1918)
 Collection Dr. W. R. Valentiner, Detroit

*41 MODERN BOHEMIA (1924)
 Collection the Folkwang Museum, Essen

Ernst Ludwig Kirchner. Born in Aschaffenburg 1880. To Dresden in 1901 where he studied architecture. Turned to painting in 1905. Formed with Heckel and Schmidt-Rottluff the *Brücke*

group. 1909–14 Berlin. Threatened with tuberculosis he has lived near Davos in the Alps since 1918.

Kirchner, to judge from his dated paintings, was the leader and most original member of the *Brücke*. He was older than either Heckel or Schmidt-Rottluff and displayed a more forceful as well as a more irascible personality. The daemonic fire which possesses him has driven him to brilliant poetry as well as to painting.

Kirchner is an expressionist by inner necessity. Few contemporary influences are apparent in his work, though at its very beginning he admired Hodler and Edvard Munch. By 1903 he was working in an expressionist style with arbitrary color and distorted drawing, inspired doubtless by primitive art which he was one of the first artists in Europe to appreciate. *Street Scene* (No. 38) and *Rhine Bridge* (No. 39) painted just before the War are of his middle period. The composition in slightly curving verticals, the rapid hatching of the brushwork and above all the acid color schemes of lavender and lemon yellow are peculiarly Kirchner's. *Mountain Landscape* (No. 40) of four years later marks a transition to the style of *Modern Bohemia* of 1924 (No. 41) in which the color is composed as if in a mosaic of vertical and horizontal bricks.

While the other members of the *Brücke* have changed gradually from expressionism to a more ordinary vision, Kirchner has turned recently toward a more abstract imaginative art.

Kirchner is represented by paintings in the museums of thirteen cities: Berlin, Chemnitz, Dresden, Elberfeld, Essen, Frankfort on the Main, Halle, Hamburg (Art Gallery and Museum of Fine and Applied Arts), Jena, Mannheim, Stuttgart, Wiesbaden, Vienna (Modern Gallery).

PAUL KLEE

42 ANGLER (1921), *watercolor*
Collection the National Gallery, Berlin

*43 TWITTERING MACHINE (1922), *watercolor*
Collection the National Gallery, Berlin

*44 MA (1922), *watercolor*
Collection Bernard Koehler, Berlin

45 LIMITS OF REASON (1927), *watercolor*
Private Collection Alfred Flechtheim, Berlin

46 THE HERDSMAN (1929)
Collection the Flechtheim Gallery, Berlin

Paul Klee. Born near Berne, Switzerland in 1879, father a Bavarian musician, mother southern French. Studied in Munich under Franz Stuck 1898. Italy 1901; Munich 1906–1914. In 1912 joined Kandinsky and Franz Marc in the Blue Rider group which held exhibitions in Munich and Berlin. Visit to Paris in 1913; met Apollinaire, Picasso, Delaunay. The War, 1915–1919. Professor

at the Bauhaus Academy, first at Weimar and then at Dessau, 1920-29. Now professor in Düsseldorf.

Klee learned little from Stuck but more from the graphic art of Kubin and the Belgian, Ensor. About 1910 he came to know the Russian Kandinsky and Franz Marc. As early as 1903 Klee's work was fantastic. Before the War he passed through a period of experiment in abstract color composition to which he has returned from time to time. His most important works however are those which anticipate by many years the ideas of the contemporary Parisian surrealists. Like them he is concerned primarily with an invented world full of incredible paradox or of spontaneous fantasy.

Klee has admired the drawings of children and of primitive man both prehistoric and savage. He is able to release from his subconscious mind with a minimum of censorship images controlled neither by observation nor by reason but by instinctive esthetic sensitiveness. The *Angler* (No. 42) and the *Twittering Machine* (No. 43) appeal to the mind by their exquisite absurdity: "T'was brillig and the slithy toves did gyre and gimble in the wabe."

Ma (No. 44) is one of the finest Klees in color. It is similar in conception to much of Picasso's work of some five years later, specifically the now famous *Seated Woman*. A more complex order of associations is set in motion by the *Limits of Reason* (No. 45). The concept "Limits of Reason" might be expressed mathematically or philosophically but scarcely more vividly.

Klee's importance cannot be proved except by an historical method; for his admirers his value is primarily (as is the case with Lewis Carroll) a question of quality.

Klee is represented by paintings in the museums of twenty cities: Barmen, Berlin, Breslau, Cologne, Detroit (Institute of Arts), Dresden, Düsseldorf, Essen, Frankfort on the Maine, Halle, The Hague (Kroeller-Mueller Museum), Hanover, Jena, Mannheim, Merion, Pennsylvania (Barnes Foundation), Moscow (Museum of Modern Western Art), New York (Gallery of Living Art), Saarbrücken, Stuttgart, Washington (Phillips Memorial Gallery).

PAUL KLEINSCHMIDT

47 WILD FLOWERS (1927)
Collection Mr. and Mrs. Erich Cohn, New York

*48 BRIDGE AT ULM (1929)
Collection Mr. and Mrs. Erich Cohn, New York

49 WHITE LILACS (1930), *watercolor*
Collection Mr. and Mrs. Erich Cohn, New York

50 HEAD OF RUSSIAN GIRL (1930), *watercolor*
Collection Dr. and Mrs. Eugene Klein, New York

Paul Kleinschmidt. Born at Bublitz in Pomerania 1883. Studied at the Berlin Academy 1902-04 and later in Munich. Exhibited with the Berlin Secession. Lives in Berlin.

Kleinschmidt developed under the influence of Lovis Corinth a master of a heavy rather sensual technique. His dark, low-toned early work emerged into a brilliant free palette, perhaps as a result of his admiration for Van Gogh. Kleinschmidt's interesting composition and lively brush-work is well illustrated by the *Bridge at Ulm* (No. 48) and the *Wild Flowers* (No. 47). He is also a painter of vigorous watercolors (cf. Nos. 49, 50).

Kleinschmidt is represented by paintings in the museums of Berlin, Frankfort on the Main, Mannheim, Stuttgart.

OSKAR KOKOSCHKA

*51 WOMAN WITH PARROT (1915)
Collection Bernhard Koehler, Berlin

52 ELBE AT DRESDEN, (1920)
Collection the Detroit Institute of Arts, Detroit

*53 GIRL WITH DOLL (1920)
Collection the Detroit Institute of Arts, Detroit

*54 PORT OF DOVER (1926)
Collection the Reinhardt Galleries, New York

Oskar Kokoschka. Born at Pöchlarn, on the Danube, 1886. Studied at the School for Arts and Crafts in Vienna under Klimt 1906–07. Berlin 1908–14. Eastern front 1914–15. Professor at the Dresden Academy 1918. Has painted recently in England, Italy, Egypt, Syria.

Kokoschka though Austrian by birth and education has identified himself with Germany through long years spent in Berlin and Dresden. As a result he has been far more appreciated abroad than in Vienna.

He has worked at different periods in such different manners that many enthusiasts for his early work can see little of value in his later. Under Klimt's inspiration he developed his first style of sensitive almost neurotic refinement. His characterizations of Viennese physicians, architects and artists are among the most remarkable portraits of our time.

Gradually this nervous style gave way to heavier pigments and more solid drawing although the distracted, feverish feeling in his work (as in the *Woman with the Parrot* No. 51) continued through the War. By 1920 Kokoschka's reputation, as the typical post-war German expressionist, had spread over Europe. But at this very time the pathetic quality in his work disappeared and in its place came a robust, brilliantly colored series of landscapes and figures painted rapidly with heavy brush-strokes. The *Girl with Doll* (No. 53) is an excellent example.

More recently, as in the *Port of Dover* (No. 54), he has turned to a very free, racy, impressionist manner, gay if somewhat superficial in spirit, and sparkling in technique.

Kokoschka is represented by paintings in the museums of twenty cities: Barmen, Berlin, Bremen, Breslau, Chemnitz, Cologne, Detroit (Institute of Arts), Dresden, Düsseldorf, Essen, Frankfort on the Main, Halle, Hamburg, Krefeld, Leipzig, Mannheim, Munich, Prague, Ulm, Vienna (Modern Gallery).

FRANZ MARC

*55 RED HORSES (*about* 1909)
Collection the Folkwang Museum, Essen

*56 APES (1911)
Collection Bernhard Koehler, Berlin

57 CATS (*about* 1912)
Collection Princess Lichnowsky, Berlin

58 RESTING ANIMALS (1912)
Collection Bernhard Koehler, Berlin

59 MANDRILL (1913)
Collection the Art Gallery, Hamburg

*60 WATERFALL (1913)
Collection Bernhard Koehler, Berlin

Franz Marc. Born in Munich, 1880. Studied at the Munich Academy. Formed in 1911 with Kandinsky the group called *The Blue Rider* which was joined by other important painters including Paul Klee and Campendonk, and which held exhibitions in Munich and Berlin. Killed before Verdun, 1916.

Perhaps the most brilliant of 20th century German painters was Franz Marc. Thoroughly trained in academic technique he rebelled against it and became the leader of the second group of German expressionists. He passed rapidly from an impressionist period through a study of primitive art and of Picasso's cubist experiments to a style of his own which became increasingly abstract until the time of his death.

Marc used animals as motives for his compositions, but they were more than motives, for often he seems to have penetrated into the very spirit of the creatures which he painted. In his earlier work such as his most admired picture the *Red Horses* of 1909 (No. 55) he seems content with a magnificently decorative composition of curved lines and brilliant color. In the *Apes* (No. 56) and the *Cats* (No. 57) he becomes more interested in the characteristics of his subjects. By 1912 he had adopted a cubistic formula by which he interrupts realistic drawing by an interplay of arbitrary angles and straight lines as in the *Resting Animals* (No. 58). In the famous *Mandrill* of 1913 (No. 59) he submerges the grotesque color scheme of the animal itself in a kaleidoscopic pattern of line and color. The *Waterfall* (No. 60) was painted only shortly before Marc began to experiment with complete abstraction, though of a nature very different from that of his companion in arms, Kandinsky.

It is superfluous to comment upon Marc's decorative color sense and upon the enthusiasm and *joie de vivre* of his design. By his death Germany and the world of art suffered an irreparable loss.

Marc is represented by paintings in the museums of ten cities: Berlin, Cologne, Düsseldorf, Essen, Frankfort on the Main, Halle, Hamburg, Mannheim, Moscow (Museum of Modern Western Art), and Munich.

PAULA MODERSOHN-BECKER

*61 SELF PORTRAIT IN A STRAW HAT (*about* 1905)
 Collection the Folkwang Museum, Essen

62 SELF PORTRAIT (1907)
 Collection the Folkwang Museum, Essen

Paula Modersohn-Becker. Born in Dresden 1878. Studied in Bremen and Berlin. Visited Paris 1900. Married the painter, Otto Modersohn, 1901, and lived at Worpswede, near Bremen, till her death in 1907.

Several years before Matisse, Picasso, or Derain, Paula Modersohn came to appreciate the art of Cézanne, van Gogh, and Gauguin. The influence of the first two is suggested in her earlier work such as the *Self Portrait in a Straw Hat* (No.61), while Gauguin seems to have interested her at the time of the later *Self Portrait* (No.62) of 1907. She maintained, however, her own distinct qualities of sincerity, warmth, and intimacy. She died after a career of eight years, at the age of twenty-nine, one of the most advanced and promising painters in Germany.

Two houses have been converted into galleries devoted to Paula Modersohn's memory; one is her home in Worpswede, the other a house in the Böttcherstrasse in Bremen established by Ludwig Roselius. She is also represented by paintings in eight museums: Berlin, Bremen, Cologne, Elberfeld, Essen, Frankfort on the Main, Hamburg, and Stuttgart.

JOHANNES MOLZAHN

63 JANUS (1930)
 Collection the Artist

*64 BEATRICE III (1930)
 Collection the Artist

Johannes Molzahn. Born at Duisburg in Westphalia 1892. Switzerland 1909-14. The War, 1914-18. Exhibited at the Sturm Gallery 1916. Professor, Magdeburg School of Applied Art 1923-28; since then, Breslau School of Arts and Crafts.

Molzahn, though his art is allied to that of Baumeister and Schlemmer, has developed independently. For a time, perhaps influenced by Italian futurism, he painted compositions of mechanical elements using not the superficial decorative aspects of machinery as did Léger, but rather the

dynamics of machinery as they appear to the eye in pulleys, wheels and transmission belts. Some-thing of this mechanical quality persists in his later work in which stylized silhouettes, sections, and fragments of human figures are composed in rhythmic relations. Recently Molzahn has en-riched the surfaces of his paintings by a variety of means such as sand mixed in the pigment, stippling, and striations made, perhaps, with the teeth of a comb. Molzahn's reputation in Ger-many and Paris is rapidly increasing.

Molzahn is represented by paintings in the museums of Breslau, Essen, Hanover and Karlsruhe.

OTTO MUELLER

*65 GIRLS BATHING (1921)
Collection Dr. W. R. Valentiner, Detroit

66 GIPSIES WITH A SUNFLOWER (*about* 1929)
Courtesy the Silesian Museum of Pictorial Arts, Breslau

67 VILLAGE STREET WITH BROOK AND TWO BATHERS (*about* 1929)
Courtesy the Silesian Museum of Pictorial Arts, Breslau

Otto Mueller. Born 1874 at Libau in Silesia. Joined the Dresden *Brücke* group in 1910. Until his recent death (autumn 1930) a teacher in the Breslau Art High School.

Otto Mueller learned much from his fellow members of the *Brücke*, especially from Kirchner. During many years, until about 1925, Mueller painted a long series of compositions of straw colored, slender, angular nudes against thinly painted yellow, green, and blue landscapes. They are monotonous when seen in quantity but canvases such as the *Girls Bathing* (No. 65) when stud-ied separately seem endowed with a quiet idyllism which holds its own remarkably by contrast with Kirchner's dissonances and Schmidt-Rottluff's resounding clangor.

Toward the end of his life, Mueller turned to a darker, muffled palette of nut browns, ochres, dull orange, and green. His subjects too became more varied and exotic as in the *Gipsies with a Sunflower* (No. 66). At the time of his death Mueller's art was gaining in strength and quality—which can scarcely be said of the current output of several other members of the *Brücke*.

Mueller is represented by paintings in eleven museums: Berlin, Breslau, Chemnitz, Cologne, Elberfeld, Erfurt, Essen, Frankfort on the Main, Hamburg, Munich-Gladbach, and Stuttgart.

EMIL NOLDE

*68 MASKS (1911)
Collection the Folkwang Museum, Essen

69 DEATH OF MARY OF EGYPT (1912)
Collection the Folkwang Museum, Essen

*70 INDIAN DANCERS, (1915)
 Collection Dr. W. R. Valentiner, Detroit

71 FARM (1920), *watercolor*
 Collection Dr. W. R. Valentiner, Detroit

72 BOATS (*about* 1926), *watercolor*
 Private Collection, New York

73 SUNFLOWERS AND ROSES, *watercolor*
 Collection Dr. F. H. Hirschland, New York

Emil Nolde. Born near Tondern in Schleswig, 1867, the son of a well-to-do farmer. Studied in Flensburg, 1884, and worked later in St. Gall, Munich, Paris, Copenhagen. Has lived on his farm in North Schleswig in the summer and in Berlin in the winter since 1902. Exhibited with the *Brücke* group in 1906 and 1907. Russia, Siberia, China, Japan, and the South Seas 1913.

Nolde's art developed gradually with little trace of outside influence. His early pictures of landscapes and flowers are sombre in tone with only an occasional prophecy of his later style. About 1906, perhaps through interchange of ideas with the *Brücke* group, his colors became bolder and more arbitrary. By 1909 in the famous *Last Supper* of the Halle Museum his expressionism had come into full vigor. This was the first of an extraordinary series of biblical painting in which color of unequalled volume and resonance increases the power of deeply felt subject matter. *Masks* (No.68) of 1911 pays homage to the African and Melanesian art from which Nolde learned so much. The *Death of Mary of Egypt* (No.69) and *Indian Dancers* (No.70) excellently represent his style which has changed little during the fifteen years since they were painted.

Nolde is one of the foremost masters of watercolor in Germany; in the three examples included in the exhibition (Nos. 71, 72, 73) he attains remarkable vibrancy and lushness.

The resounding diapason of his color is obvious, but his spirit and his treatment of subject matter as in the *Death of Mary of Egypt* is difficult on first experience. To understand his work it is almost necessary to know something of his personality in which the peasant, the mystic, the hermit and the prophet are mingled. Of the artist (that is, of himself) Nolde writes: "The devil lives in his limbs, divinity in his heart. Who can realize these powers fighting with one another in endless conflict! Behind walls lives the artist, rarely flying, often in his snail shell. He loves the rarest and deepest natural occurences, but also the bright, ordinary reality, the moving clouds, the blooming, glowing flowers, the living creatures. Unknown, unknowing people are his friends, gipsies, Papuans . . . He sees not much, but other men see nothing."

Nolde is represented by paintings in the museums of eighteen cities: Basel (Municipal Picture Collection), Berlin, Breslau, Chemnitz, Dresden, Erfurt, Essen, Frankfort on the Main, Halle, Hamburg, Kiel, Leipzig, Mannheim, Munich-Gladbach, Oldenburg, Stuttgart, Vienna, and Wiesbaden.

MAX PECHSTEIN

*74 LIFE BOAT (1913)
 Collection the National Gallery, Berlin

75 DOUBLE PORTRAIT (1919), *watercolor*
 Collection J. B. Neumann, New York

76 LANDSCAPE (1921)
 Collection Ralph Booth, Detroit

Hermann Max Pechstein was born at Zwickau in 1881. After studying in the Dresden Academy he worked in Italy where he discovered Giotto, and in Paris where the influence of van Gogh, Gauguin and Matisse rapidly changed his art from that of impressionist to expressionist. In 1906 he became a member of the Dresden *Brücke* group, absorbed many of their ideas and during the next ten years became the best known among German expressionists. Bold, eclectic, clever, he did much to popularize the ideas of his more reticent and uncompromising companions. To-day his reputation has become somewhat deflated so that there is now a tendency to underrate his art.

The *Life Boat* of 1913 (No. 74) is one of Pechstein's best known compositions. More characteristic is the lemon green tone of the watercolor *Double Portrait* (No. 75).

Pechstein is represented in the museums of seventeen cities: Berlin, Breslau, Bremen, Chemnitz, Cologne, Dresden, Erfurt, Essen, Frankfort on the Main, Hamburg, Jena, Leipzig, Mannheim, Moscow (Museum of Modern Western Art), Osnabrück, Wiesbaden, and Zürich (Art Museum).

CHRISTIAN ROHLFS

77 PORTRAIT OF A WOMAN (1919), *watercolor*
 Collection Dr. W. R. Valentiner, Detroit

78 LILIES (1919), *watercolor*
 Collection Dr. W. R. Valentiner, Detroit

*79 PRODIGAL SON (*about* 1922)
 Collection the Folkwang Museum, Essen

Christian Rohlfs. Born at Niendorf in Holstein, 1849. Studied at Weimar Academy. In 1901 invited by Ernst Osthaus to teach in the Art School at Hagen, where he still lives.

In Osthaus' collection (which was later to form the large part of the Folkwang Museum in Essen) Rohlfs found major works by Daumier, Cézanne, and van Gogh so that in his sixties he was able to transform his art, becoming paradoxically the oldest and one of the first German expressionists.

Rohlfs' art like Nolde's and Barlach's is colored by deep religious sentiment not merely because, as in the *Prodigal Son* (No. 78) the subject is biblical, but because it is handled with a profound concern for the human emotions involved. Rohlfs' stained-glass-like color is carried into the curiously drenched technique of his watercolors.

Rohlfs is represented by paintings in the museums of twelve cities: Berlin, Düsseldorf, Elberfeld, Erfurt, Essen, Frankfort on the Main, Hagen, Hamburg, Kiel, Mannheim, Munich-Gladbach, and Wiesbaden.

OSKAR SCHLEMMER

*80 THREE WOMEN (1928)
Collection the Flechtheim Gallery, Berlin

81 RED FIGURES (1928)
Collection the Flechtheim Gallery, Berlin

Oskar Schlemmer. Born in 1888 in Stuttgart where he studied painting together with Willy Baumeister under Adolf Hölzel. Professor of Theater Arts and Ballet at the Bauhaus, Weimar, 1921, and later in Dessau. Since 1929 Professor in the Breslau Academy.

From Adolf Hölzel Schlemmer learned to study Cézanne. By 1913 he had become acquainted with Picasso's cubism and later (1915) with the more abstract principles of Kandinsky and Klee. By 1920 both he and Baumeister had turned from easel painting to wall composition of simplified human and geometrical forms in colored plaster low relief. After joining the staff of the Bauhaus, Schlemmer became more and more concerned with experiment in the theater. He designed and produced several highly original and brilliant mechanico-puppet-like ballets of which the *Triad* is the most often performed.

Recently Schlemmer's paintings have commanded increasing interest. *Three Women* (No. 80) is a composition of figures reduced to sections of cones and spheres and placed at geometrical intervals. His rich, stained-wood color and piquant mannequin-like style preserve his work from a too-cerebral quality.

Schlemmer's versatility is further illustrated by his experiments with sculpture. The *Grotesque* (No. 121) is another demonstration of his principles of curvilinear composition and perfection of craftsmanship.

Schlemmer is represented by paintings in the museums of Berlin, Essen, Hanover, Mannheim, and Stuttgart. He has just completed a series of mural paintings in the hall of the Minne fountain in the Essen Folkwang Museum.

KARL SCHMIDT ROTTLUFF

*82 EVENING ON THE SEA (1920)
Collection Dr. W. R. Valentiner, Detroit

83 WHEAT SHOCKS (1921)
Collection Ralph Booth, Detroit

84 ON THE SEA (1923), *watercolor*
Collection Dr. W. R. Valentiner, Detroit

85 PROMENADE
Collection Neumann-Nierendorf, Berlin

*86 THE BLUE TOWER (*about* 1926)
Private Collection, New York

Karl Schmidt-Rottluff. Born at Rottluff near Chemnitz, 1884. Studied at the Technical High School in Dresden where he met Heckel and Kirchner with whom he formed the *Brücke* group, 1905. Left Dresden 1911 for Berlin where he has since lived except during the War.

Schmidt-Rottluff's earliest work is impressionist in character. By 1907 he came to admire van Gogh, then Munch, and about the same time primitive and barbaric art. By 1910 his personal style was formed though it has since undergone several modifications.

Schmidt-Rottluff is the most consistent and perhaps the most powerful painter of the earliest group of German expressionists. His palette is in a major key of strong reds, blacks, blues, and yellows. He outlines his figures with heavy, angular contours which seem derived from the leads of stained glass or 15th century woodcuts, a technique which he employs perhaps more appropriately in his mosaics and woodcuts. Many of his paintings such as the *Wheat Shocks* (No. 83) and the *Promenade* (No. 85) are crudely magnificent decorations but sometimes as in the *Evening on the Sea* (No. 82) one senses a mood of sombre melancholy. He is a master of a bold, vigorous attack in his watercolors (Nos. 84, 86).

Schmidt-Rottluff is represented in fifteen museums: Berlin, Bremen, Breslau, Chemnitz, Cologne, Detroit (Institute of Arts), Dresden, Erfurt, Essen, Frankfort on the Main, Halle, Hamburg (Art Gallery, and Museum of Fine and Applied Arts), Jena, and Stuttgart.

GEORG SCHRIMPF

87 MOTHER AND CHILD (1923), *watercolor*
Collection J. B. Neumann, New York

*88 SLEEPING GIRLS (1926)
Collection the Municipal Museum, Munich

89 STILL LIFE WITH A JUG (1929)
Lent by the Artist, Courtesy the Municipal Museum, Munich

Georg Schrimpf. Born in Munich 1889. Wandered over Europe as a waiter, baker, coal heaver; finally became a worker in a chocolate factory in Berlin. Exhibited his first pictures at the *Sturm* gallery 1915. Has lived in Munich since 1918.

Schrimpf in spite of his adventurous youth has developed a style of extreme placidity. He is now recognized as the leader of a group of Munich painters who have been rather loosely included in the "new-objectivity" movement. Schrimpf's objectivity has, however, none of the vindictive bitterness of Dix though like Dix he has studied the paintings of the Biedermeyer period and of the 15th century Flemings. Suggestions of Schadow, Overbeck and Schwind mingle with traces of the Master of Flémalle and Picasso.

The *Mother and Child* (No. 87) and the *Sleeping Girls* (No. 88) are excellent examples of his bland color and unpretentious composition. His mild paintings are a reaction to (and may be taken as an antidote against) the turbulence of much modern art.

Schrimpf is represented by paintings in Berlin, Cologne, Düsseldorf, Erfurt, Frankfort on the Main, Gelsenkirchen, Hamburg, Mannheim, Leipzig, Munich (Municipal Gallery), Pforzheim, and Stockholm (National Gallery).

SCULPTORS

NOTE: An asterisk before a catalog number indicates that the sculpture is illustrated by a plate which bears the same number.

ERNST BARLACH

90 HEAD OF TILLA DURIEUX (1912), *bronze*
Collection the Flechtheim Gallery, Berlin

91 THE AVENGER (1923), *bronze*
Collection the Flechtheim Gallery, Berlin

92 THE RETURN (1926), *bronze*
Collection the Flechtheim Gallery, Berlin

*93 HEAD FROM THE WAR MONUMENT, GÜSTROW CATHEDRAL (1927), *bronze*
Collection E. M. M. Warburg, New York

*94 SINGING MAN (1928), *bronze*
Collection the Flechtheim Gallery, Berlin

Ernst Barlach. Born at Wedel near Hamburg, 1870. Studied at Hamburg School of Arts and Crafts, 1888, and at the Dresden Academy, 1891. Admired the work of Millet and Constantin Meunier and later about 1895 discovered van Gogh. First sculpture in wood, 1905. Visited South Russia, 1906. Since 1910 has lived at Güstrow in north Prussia.

Barlach's sculpture so far exceeds the merely formal problems and emotional restraint—or even poverty—of the work of such contemporaries as Maillol, Kolbe, and Despiau, that it is difficult to characterize his work without extravagance. He resembles van Gogh whom he admires. Van Gogh through his paintings and letters, Barlach through his sculpture, woodcuts and dramas, give vivid expression to personalities violent, passionate, religious (but without piety), Christian in their concern with human pathos, mystical in their perception of spiritual forces beneath natural appearances. But the fury which drove van Gogh to madness and death has met formidable resistance in Barlach's earthy gravity and capacity for repose and in his sense of humor which van Gogh completely lacked.

Barlach owes little to any modern artists except van Gogh. But he has studied and absorbed medieval art, especially of Germany, and has learned much from the little wooden figures carved by Russian peasants. For Barlach is primarily a sculptor in wood (though unfortunately the risk of splitting prevented his sending any but bronzes across the ocean). Ten years before the *Fauves* painters in Paris or the *Brücke* group in Dresden, Barlach had discovered primitive art and had made figures under the inspiration of distorted but highly expressive Gothic wood carvings. Since the 90's Barlach's style has changed very little. Figures of peasants dancing, singing, fight-

37

ing, dying, praying, figures of prophets, ecstatic evangelists, form a long and varied series. A moving, almost biblical simplicity characterizes *The Return* (No. 92). *The Head* (No. 93) with its large closed eyes suggests acquaintance with Romanesque bronzes such as the famous Werden crucifix. The *Singing Man* (No. 94), possibly the finest Barlach in the exhibition, represents his robustness, his capacity for laughter and his power of expressing an inner vitality through gross physical forms.

Barlach is represented by three public monuments: the War Memorial in Güstrow Cathedral, figures in the Cathedral at Magdeburg, and the Berlin Deutsches Theater, and by sculpture in fifteen museums: Berlin (National Gallery), Bremen, Chemnitz, Cologne, Danzig, Dortmund, Dresden (Albertinum), Duisburg, Essen, Frankfort, Kiel, Munich, Nuremburg, Stuttgart, Vienna (Modern Gallery).

RUDOLF BELLING

*95 TRIAD (1919), *mahogany*
 Collection the Flechtheim Gallery, Berlin

96 HEAD IN MAHOGANY (1921)
 Collection Josef von Sternberg, Hollywood

97 PORTRAIT OF ALFRED FLECHTHEIM (1922), *bronze*
 Collection Josef von Sternberg, Hollywood

98 SCULPTURE (1923), *brass and iron*
 Collection the Flechtheim Gallery, Berlin

99 HEAD (1925), *brass*
 Collection the Flechtheim Gallery, Berlin

*100 PORTRAIT OF JOSEF VON STERNBERG (1930), *silvered bronze*
 Collection Josef von Sternberg, Hollywood

Rudolf Belling. Born in Berlin, 1886. Worked as an assistant to a figurine modeler and later in a Theater Scenery workshop. Studied at the Berlin Academy 1911-12. Lives in Berlin.

Belling is an inventor, an experimentalist. He works slowly, producing little more than one or two figures a year. But each work possesses a finality of conception and a perfection of crafts-manship which makes his position unique in German sculpture.

Triad (No. 95) dating from 1919, his most famous work, suggests an acquaintance with Archipenko, the ingenious Russian sculptor who was working in Berlin shortly after the war. The musical title, *Triad* (Dreiklang) is valuable in that it helps to keep the mind of the observer from attempting to see in these three shapes mere distortions of human figures. They are, rather, "abstract" sculptural forms which seem enclosed in an invisible sphere from which they threaten

to burst with a dynamic centrifugal force. *Sculpture* (No. 98), 1923, is a reduction of a human head to the forms of solid geometry—spheres, hemispheres, and cylinders. The result is an arrangement of metallic surfaces which seem half mask and half machine, comical at first glance, sinister at second. The elegance of the woman's *Head* (No. 99) may be contrasted with the grotesque mahogany gargoyle (No. 96).

In the *Portrait of von Sternberg* (No. 100) Belling is most original for he handles parts of the head with forceful naturalism and then unexpectedly permits solid surfaces to give way to voids with all the license ordinarily used in a more abstract subject. The *Portrait of Flechtheim* (No. 97) carries to an extreme this method of modelling by highlights of bronze without continuing the solid surfaces into the "darks." In spite of the tricky shorthand technique the portrait is an excellent characterization.

Belling is represented by sculpture in seven museums: Berlin (National Gallery), Cologne, Detroit (Institute of Arts), Essen, Hamburg, New York (Museum of Modern Art), and Stuttgart. Belling is also represented in the following public and commercial buildings on the Continent: Berlin (The House of the Federation of German Publishers and Town Hall), the Hague (The De Volhaarding Department Store), and Harburg (Town Hall).

ERNESTO DE FIORI

*101 SOLDIER (1918), *artificial stone*
 Private Collection Alfred Flechtheim, Berlin

102 ENGLISH WOMAN (1925), *bronze*
 Collection Mr. and Mrs. Erich Cohn, New York

103 HEAD OF DEMPSEY (*about* 1926), *terra cotta*
 Collection the Weyhe Gallery, New York

*104 FLEEING WOMAN (1927), *bronze*
 Collection the Flechtheim Gallery, Berlin

*105 MARLENE DIETRICH (1931), *plaster with some color*
 Collection the Artist, Courtesy the Flechtheim Gallery, Berlin

Ernesto de Fiori. Born in Rome 1884. Entered Munich Academy, 1903. Studied painting under influence of Hodler. Rome 1904. London 1908. Paris 1911, where Maillol's art persuaded him to become a sculptor. Since 1914 a German citizen. Lives in Berlin.

Although Fiori's education was international he has for the last fifteen years become identified with German art. Comparison with Kolbe, his more popular rival, is enlightening. Both men confine themselves to single figures and portraits. Like Kolbe, Fiori has turned from an early softer and more modelled style to the simplicity of surface and archaic almost Egyptian rigidity of

39

the *Soldier* (No. 101), which is paralleled by Kolbe's *Assunta* (No. 108), and then back again to a style in which one can feel traces of the thumb on clay as in the *Fleeing Woman* of 1927 (No. 104) or the charming head of *Marlene Dietrich* (No. 105) finished a few weeks ago. Of the two, Kolbe seems more sure of himself, more classical in temperament but his figures seem more repetitious, imbued with sentiment but without personality. Fiori's style changes, he experiments. Each of his figures has a character which can be given only by a sculptor who is genuinely interested in the individuality of his model. Certain of Fiori's figures, such as the *Soldier* (No. 101) and the *English Woman* (No. 102), are among the most vividly unforgettable in contemporary sculpture.

Ernesto de Fiori is represented by sculpture in the museums of twenty-three cities: Berlin, Bremen, Breslau, Chemnitz, Cologne, Danzig, Detroit, Dortmund, Dresden, Duisburg, Düsseldorf, Elberfeld, Frankfort on the Main, Hamburg, London (National Gallery, Millbank—"Tate"), Lübeck, Mannheim, Mühlheim, Münster, Rotterdam (Boymans Museum), Stettin, Ulm, Vienna (Modern Gallery), and in the Théâtre des Champs Elysées in Paris.

GEORG KOLBE

106 HEAD OF DANCER (1912), *bronze*
Unique cast of the head of the figure in the National Gallery, Berlin
Collection Mr. and Mrs. Erich Cohn, New York

107 SEATED GIRL (1917), *bronze*
Collection Mr. and Mrs. Erich Cohn, New York

*108 ASSUNTA (1921), *bronze*
Collection the Detroit Institute of Arts, Detroit

*109 GRIEF (1921), *bronze*
Collection Mr. and Mrs. Erich Cohn, New York

110 SEA NYMPH (1921), *bronze*
Collection Dr. F. H. Hirschland, New York

*111 WOMAN DESCENDING (*about* 1927), *bronze*
Collection the Weyhe Gallery, New York

112 YOUNG GIRL (1929), *bronze*
Collection the Weyhe Gallery, New York

113 STANDING BOY (*about* 1929), *bronze*
Collection the Weyhe Gallery, New York

Georg Kolbe. Born April 15, 1877, at Waldheim in Saxony. Studied painting and drawing in Dresden Academy and in Munich. Paris, 1898, and Rome till 1900 where he turned to sculpture. Has lived since 1904 in Berlin where he teaches in the Academy.

Kolbe's earlier work, such as the *Head of a Dancer* of 1912 (No. 106), suggests the subtle, veiled modelling of Rodin. Otherwise his development has been practically free from contemporary influences. He may well, however, have studied archaic Greek or eleventh century Rhenish sculpture before attaining to the ascetic severity of the great *Assunta* of 1921 (No. 108). Of the same time are two small figures, *Grief* (No. 109) and *Sea Nymph* (No. 110), both extraordinary studies in the complex rhythmic arrangement of limbs and body. More recently as in the *Woman Descending* of 1927 (No. 111) Kolbe has given a richer, a more sensuous surface texture to his work.

Kolbe rarely informs his figures with strong emotion. Even when their postures are violent they seem posed rather than the convincing expression of pain or joy. But he as rarely indulges in the purely physical and sometimes empty objectivity of his French contemporary, Maillol. Occasionally, as in the *Assunta*, one senses an intense inner feeling but the gentle rather relaxed sentiment of the *Young Girl* (No. 112) is more typical.

Kolbe's great knowledge, his virtuosity in modelling, his inventiveness in posing his figures, are admirable qualities. But equally important are the mild and gracious spirit, the untroubled tenderness with which he repeats his variations upon the theme of youth or maiden.

Kolbe is one of the most popular of living sculptors and one of the most prolific. His bronzes are in twenty-six German and nine foreign museums. Over forty-five private collectors from Moscow to Hollywood own his work. He has done fifteen public monuments.

George Kolbe is represented by sculpture in thirty-five museums: Berlin (National Gallery), Bielefeld, Bremen, Breslau, Chemnitz, Chicago (Art Institute), Cologne, Danzig, Denver (Museum), Detroit (Institute of Arts), Dresden (Albertinum), Düsseldorf, Duisburg, Elberfeld, Erfurt, Essen, Frankfort on the Main, Freiburg, Hagen, the Hague (Modern Museum), Hamburg, Hanover, Leipzig, Lübeck, Magdeburg, Manchester (Museum), Mannheim, Marburg, Munich, Nuremburg, Rome, Rotterdam (Boymans Museum), Stockholm (National Museum), Vienna (Modern Gallery), and Wiesbaden.

GERHARD MARCKS

114 RUNNER (1924), *bronze*
Collection the Artist

*115 ADAM (1924–25), *wood*
Collection the Artist

116 HEAD OF CRODEL (1927), *bronze*
Collection the Artist

117 MASK OF MARIA (1927), *bronze*
Collection the Artist

118 PROPHET (1929), *plaster*
Collection the Artist

Gerhard Marcks. Born 1889 in Berlin. Studied under the sculptor Scheibe and met Kolbe and August Gaul. From 1912 to 1918 "more or less a soldier" (his own words). Worked on wood-cuts and wood carvings while still a war invalid at the Bauhaus Academy at Weimar. Since 1925 a professor at the School of Applied Art, Giebichenstein, Gimritz, near Halle.

Marcks is not yet well known even in Germany where twenty other sculptors have greater reputations. The architectonic structure of the *Adam* (No. 115) and the crude figure of the *Prophet* (No. 118) make no bid for popularity. But the prophet's tower-like form, the ponderous dignity and insistence of his extended arm have perhaps no equal in modern German sculpture. Marcks' art has developed slowly. His power has only recently become evident.

Gerhard Marcks is represented by sculpture in the museums of Essen and Halle.

OSKAR SCHLEMMER

(For biography and notes see Catalog of Painters)

119 GROTESQUE (1923), *wood*
Collection Neumann-Nierendorf, Berlin

RENÉE SINTENIS

*120 SELF PORTRAIT (1926), *terra cotta*
Collection the Weyhe Gallery, New York

121 THE MARATHON RUNNER, NURMI (1926), *bronze*
Collection the Weyhe Gallery, New York

122 GALLOPING COLT (1929), *bronze*
Collection the Weyhe Gallery, New York

123 YOUNG OX (1929), *bronze*
Collection the Weyhe Gallery, New York

Renée Weiss-Sintenis. Born in Glatz in Silesia in 1888. Studied at the Berlin School of Arts and Crafts between 1908–1911. She lives in Berlin.

Lambs, fauns, kids, young camels and elephants, calves, foals, cubs and puppies—a long series of little bronzes whose unpretentious charm make comment superfluous and their creator the most distinguished German sculptress. She has also done more "serious" work, figures of athletes such as *Nurmi* (No. 121) and portraits such as the very sensitive *Self Portrait* (No. 120).

Sintenis is represented by sculpture in the museums of twenty-seven cities: Aachen, Berlin (National Gallery, also in the Deutsches Theatre), Bremen, Chemnitz, Chicago (Art Institute), Cologne, Danzig, Denver (Museum), Detroit (Institute of Arts), Dortmund, Dresden, Düsseldorf, Elberfeld, Frankfort on the Main (Municipal Gallery), the Hague, Helsingfors (Atheneum), Leipzig, London, Lübeck, Mannheim, Munich, Oldenburg, Oslö (Museum), Rotterdam (Boymans Museum), Stockholm (National Museum), Vienna (Modern Gallery), and Winterthur (Museum).

ILLUSTRATIONS

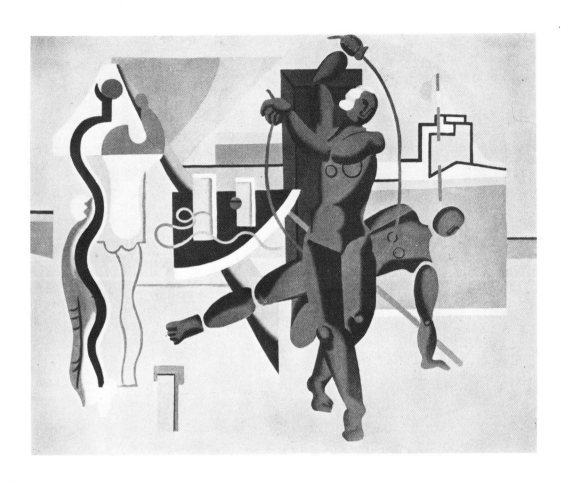

BAUMEISTER 1

Athletic Field (1930). *Oil on canvas, 31½ x 39⅜ inches*
Collection Flechtheim Gallery, Berlin

7 BECKMANN

Self Portrait with a Cigar (1923). *Oil on canvas, 23¾ x 15¾ inches*
Collection Dr. F. H. Hirschland, New York

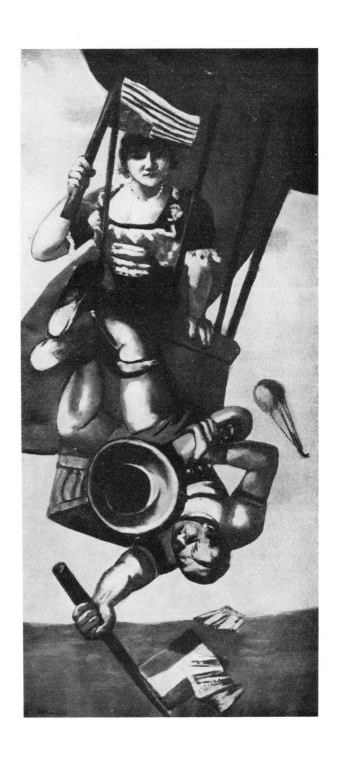

BECKMANN 8
BALLOON ACROBATS (1925)
Collection Claus Gebhardt, Elberfeld

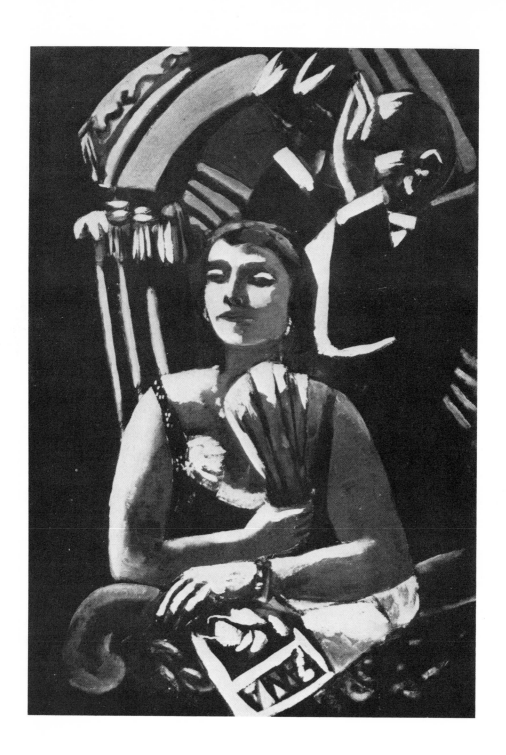

9 BECKMANN

THE LOGE (1928)

Collection Dr. Oppenheim, Berlin

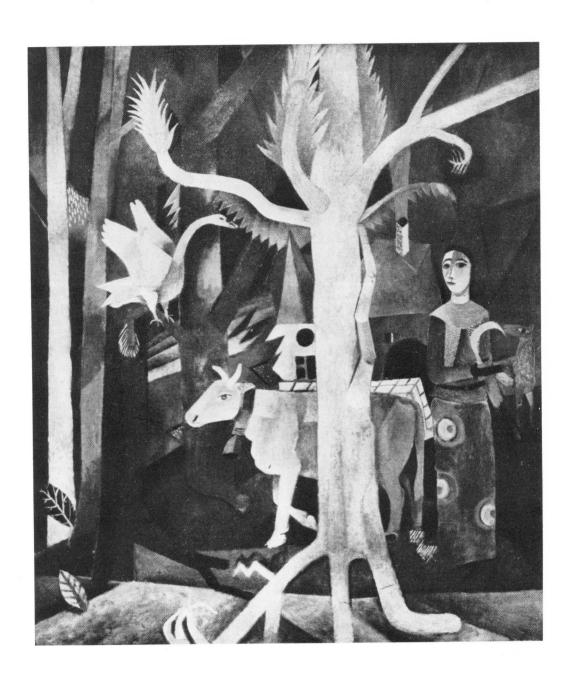

CAMPENDONK 11
THE WHITE TREE (1925)
Collection Miss Katherine Dreier, New York

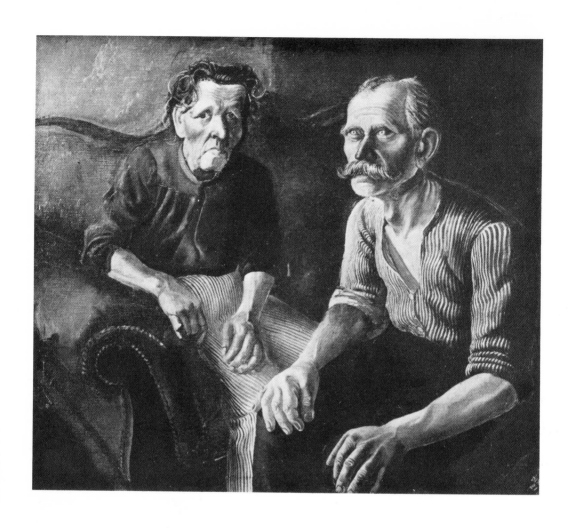

13 DIX

PORTRAIT OF THE ARTIST'S PARENTS (1921). *Oil on canvas, 39 x 45 inches*
Collection Wallraf-Richartz Museum, Cologne

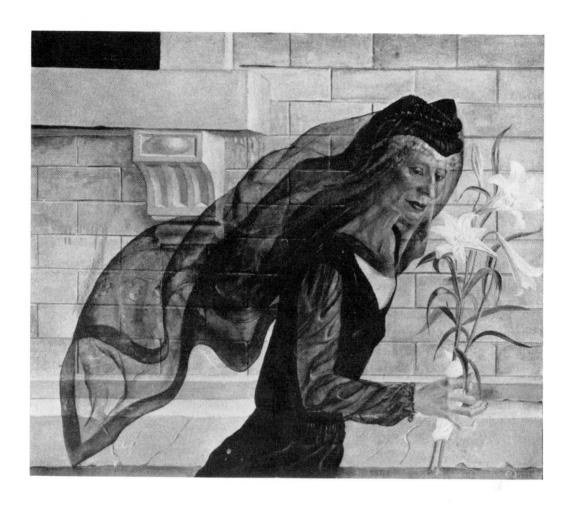

DIX 14
THE WIDOW (1925)
Collection the Art Gallery, Mannheim

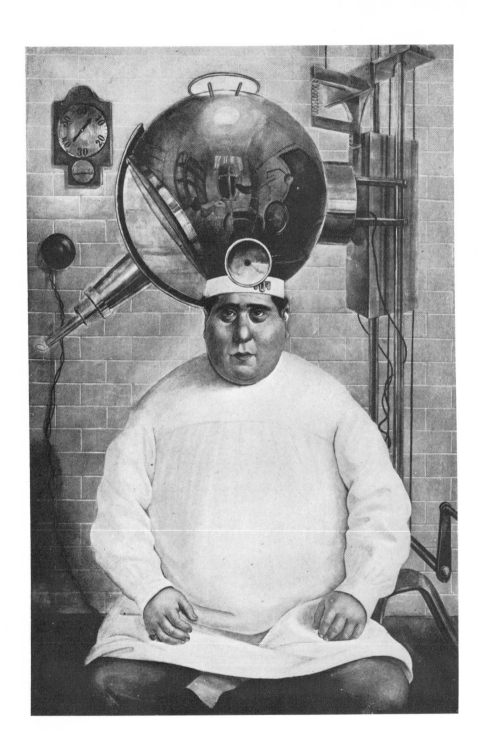

15 DIX

DR. MEYER-HERMANN (1926)
Collection the Artist

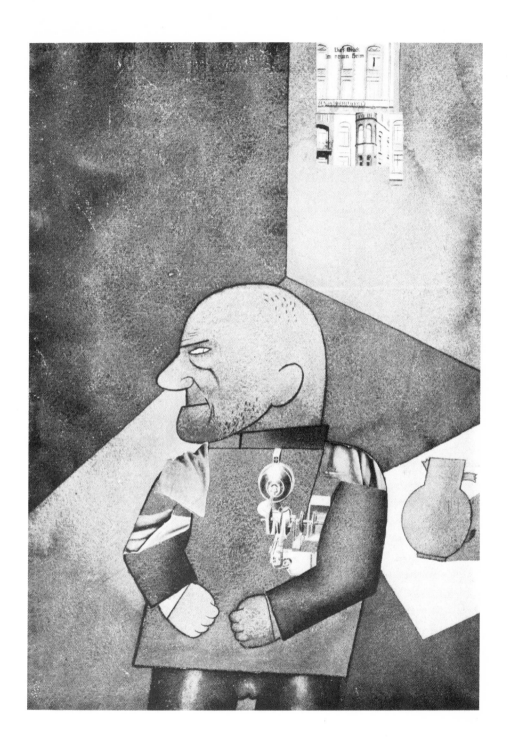

GROSZ 18

The Engineer Heartfield (1920). *Watercolor and clipping-montage, 16 x 11½ inches*
Collection Dr. Hermann Post, New York

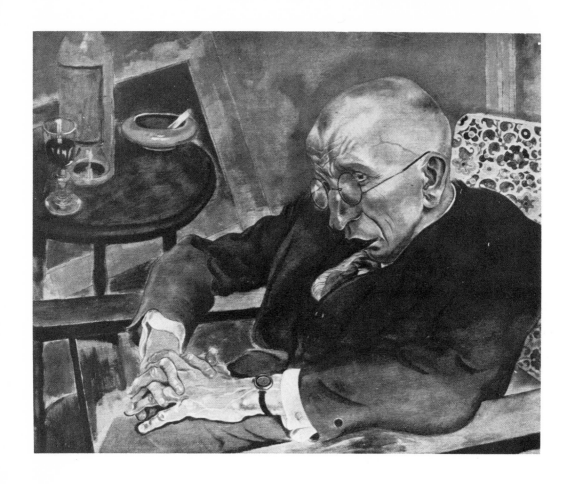

19 GROSZ

Dr. Neisse (1927). *Oil on canvas, 19½ x 28¾ inches*
Collection Flechtheim Gallery, Berlin

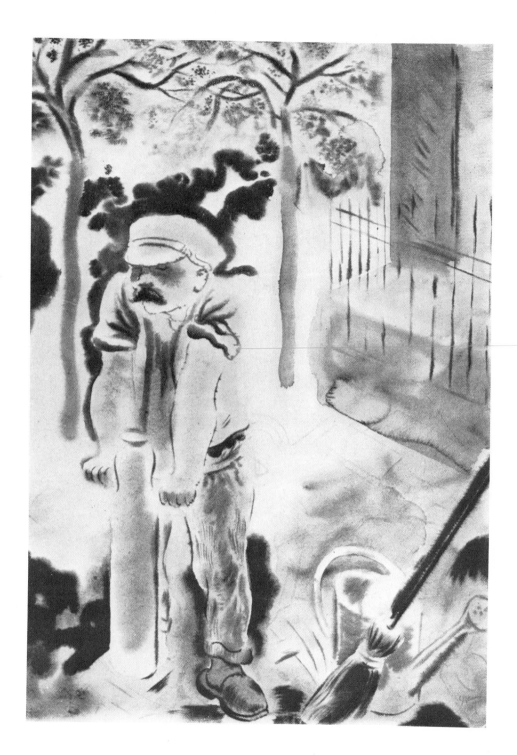

GROSZ 24

WORKING MAN (1930). *Watercolor, 26⅝ x 18⅞ inches*
Collection Flechtheim Gallery, Berlin

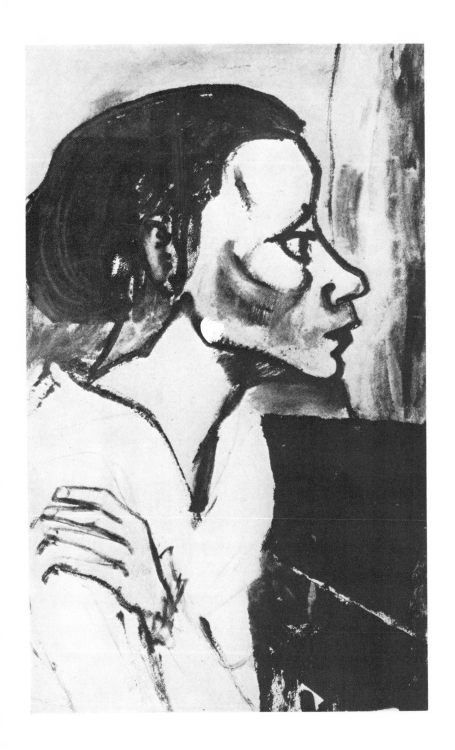

25 HECKEL

PORTRAIT STUDY (1918). *Oil on canvas, 22 x 14 inches*
Collection the Detroit Institute of Arts, Detroit

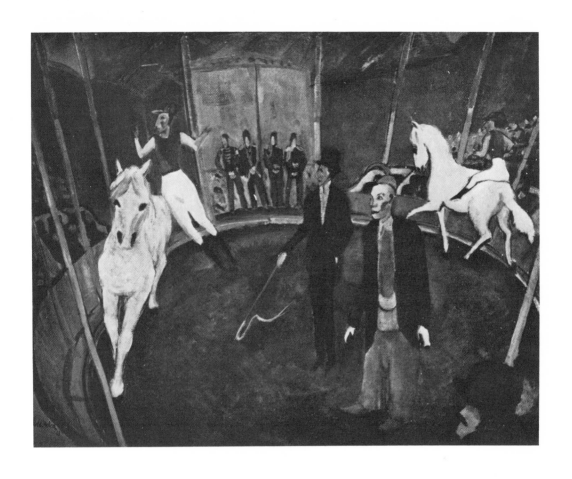

HECKEL 26

CIRCUS (1921). *Oil on canvas, 37¾ x 47¼ inches*

Collection the Artist

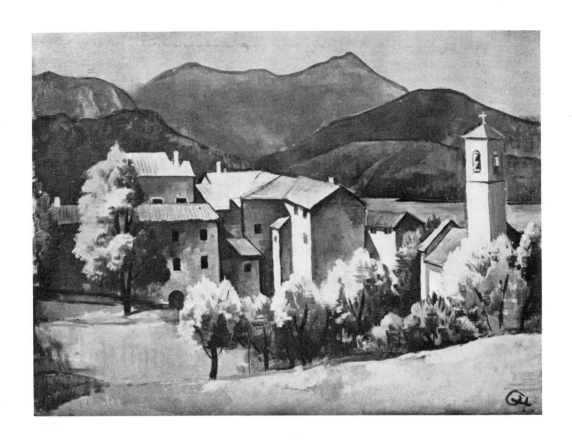

31 HOFER

MUZZANO (*about* 1925). *Oil on canvas,* 22½ x 30⅜ *inches*
Collection Wallraf-Richartz Museum, Cologne

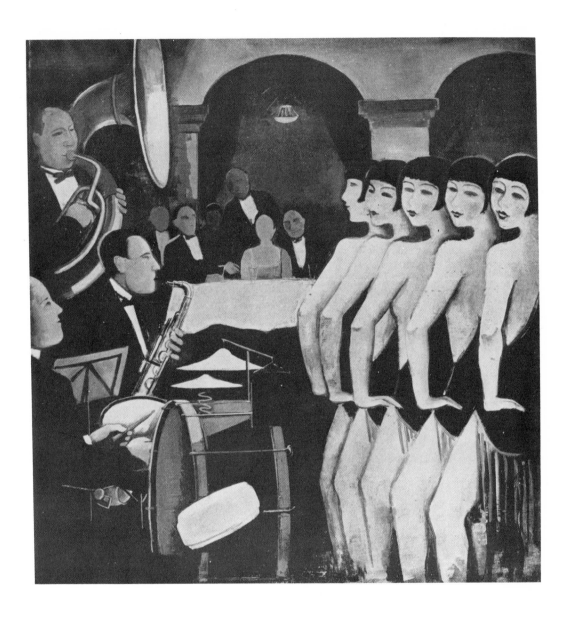

HOFER 32

NIGHT CLUB (1927). *Oil on canvas, 56 x 57⅞ inches*
Collection Flechtheim Gallery, Berlin

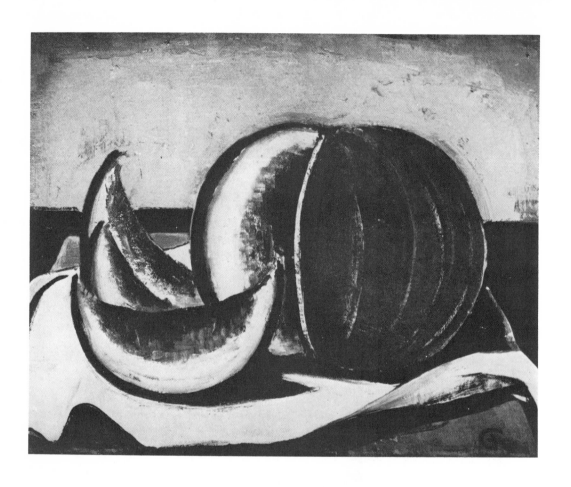

34 HOFER
 MELON (1929): *Oil on canvas 22¼ x 27¼ inches*
 Collection Flechtheim Gallery, Berlin

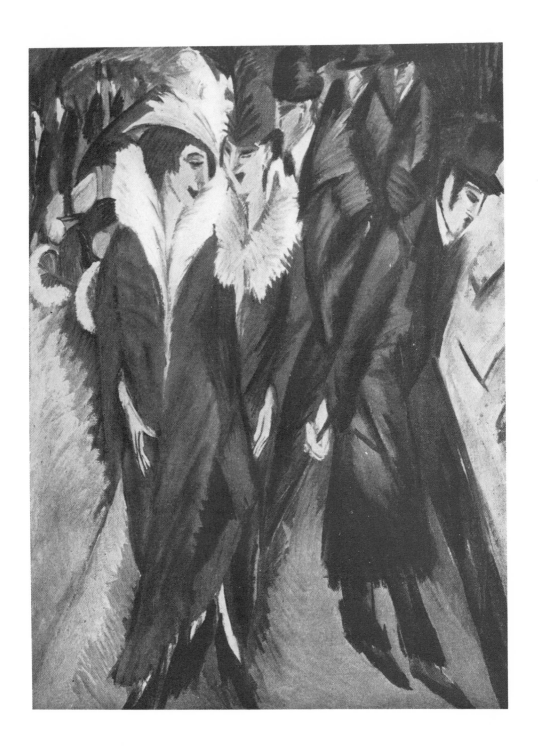

KIRCHNER 38

STREET SCENE (1913). *Oil on canvas, 46½ x 38½ inches*
Collection the National Gallery, Berlin

41 KIRCHNER

MODERN BOHEMIA (1924). *Oil on canvas, 48 x 65¼ inches*
Collection the Folkwang Museum, Essen

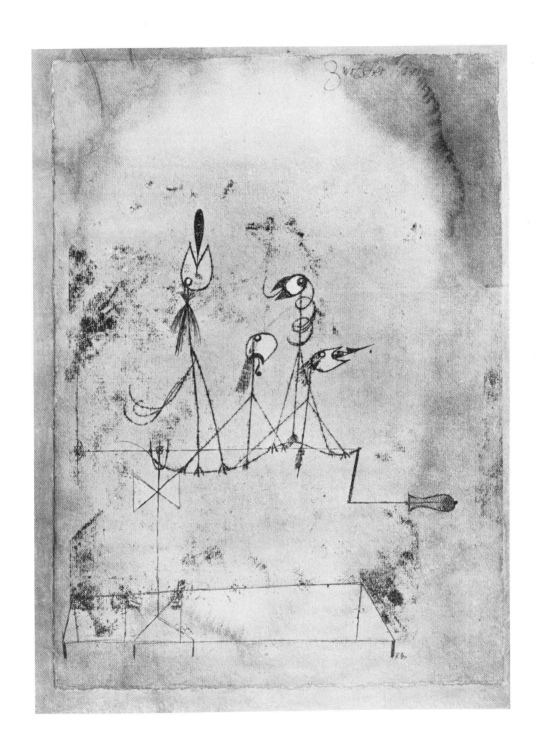

KLEE 43

TWITTERING MACHINE (1922). *Oil, 16 x 11⅞ inches*
Collection the National Gallery, Berlin

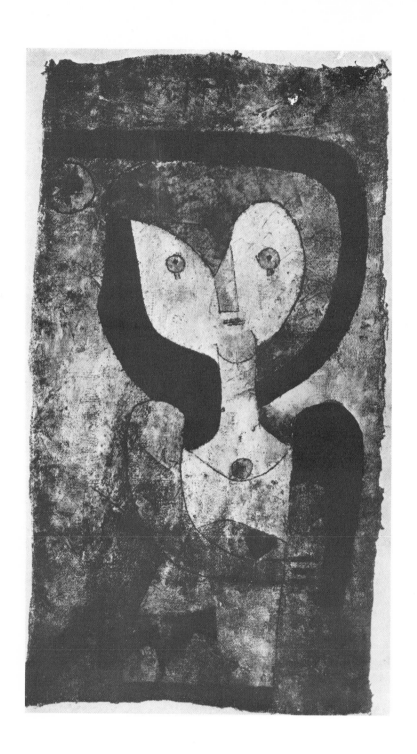

44 KLEE

Ma (1922). *Watercolor, 15¾ x 8⅝ inches*
Collection Bernard Koehler, Berlin

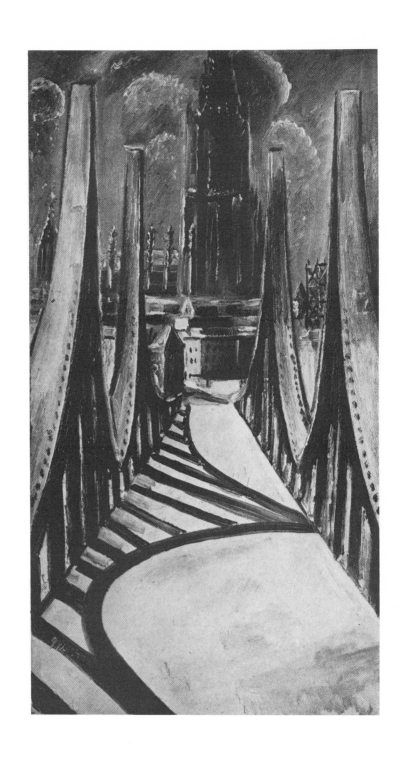

KLEINSCHMIDT 48
BRIDGE AT ULM (1929). *Oil on canvas, 15¾ x 35½ inches*
Collection Mr. and Mrs. Erich Cohn, New York

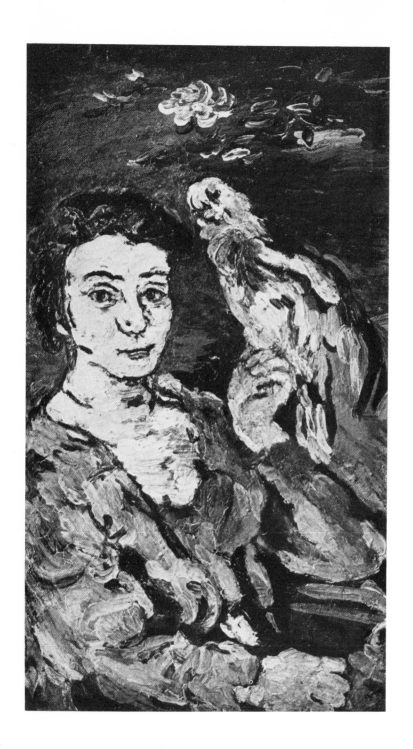

51 KOKOSCHKA

WOMAN WITH PARROT (1915). *Oil on canvas, 33 ⅛ x 20 inches*
Collection Bernard Koehler, Berlin

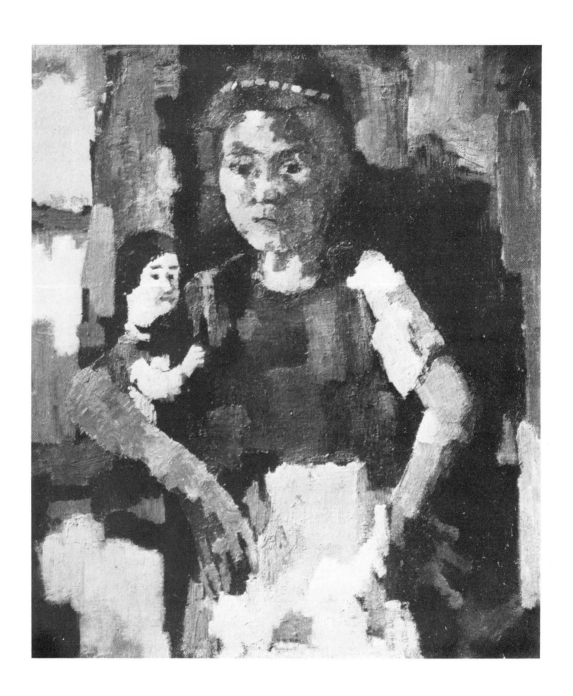

KOKOSCHKA 53

GIRL WITH DOLL (1920). *Oil on canvas, 36 x 32 inches*
Collection the Detroit Institute of Arts, Detroit

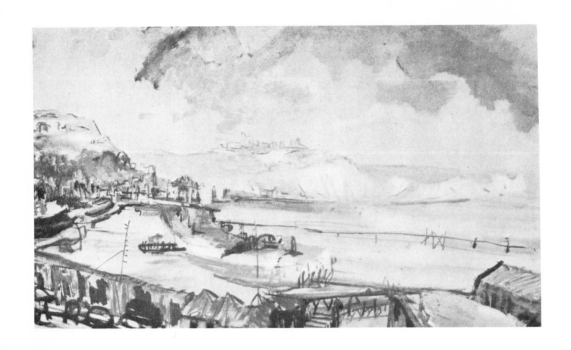

54 KOKOSCHKA

Port of Dover (1926). *Oil on canvas, 30 x 50 inches*
Collection the Reinhardt Galleries, New York

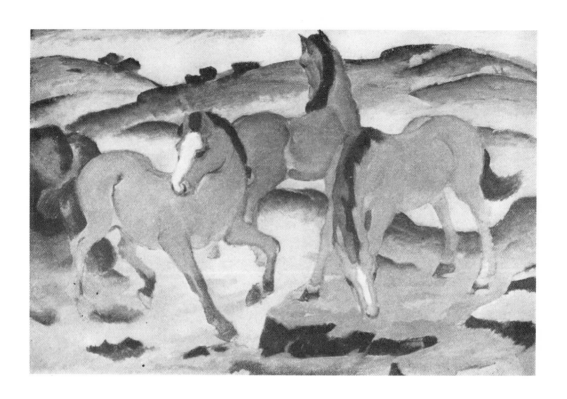

RED HORSES (*about* 1909). *Oil on canvas, 46⅞ x 71¼ inches*
Collection the Folkwang Museum, Essen

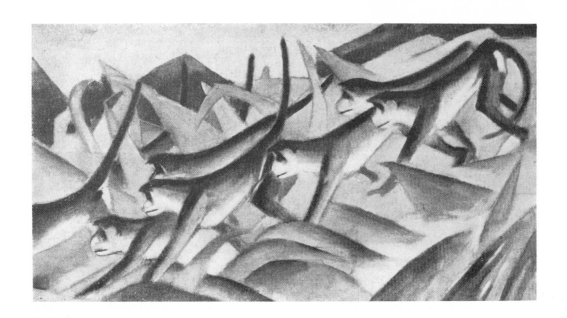

56 MARC

APES (1911). *Oil on canvas, 29½ x 52⅞ inches*
Collection Bernard Koehler, Berlin

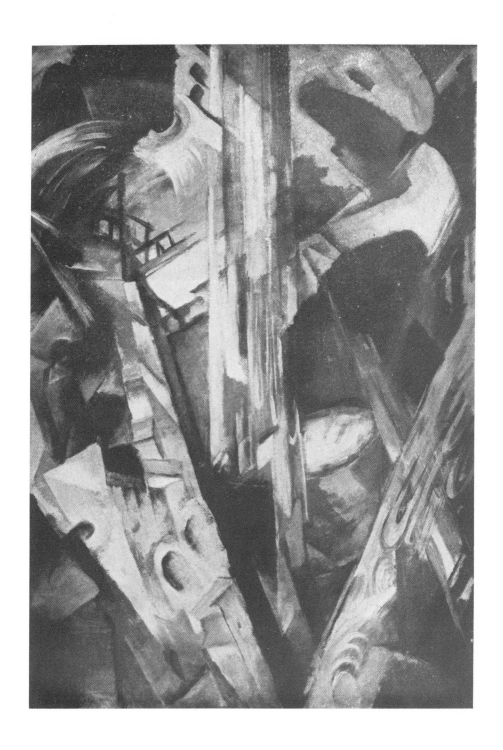

MARC 60

WATERFALL (1913). *Oil on canvas, 43¼ x 30¾ inches*
Collection Bernard Koehler, Berlin

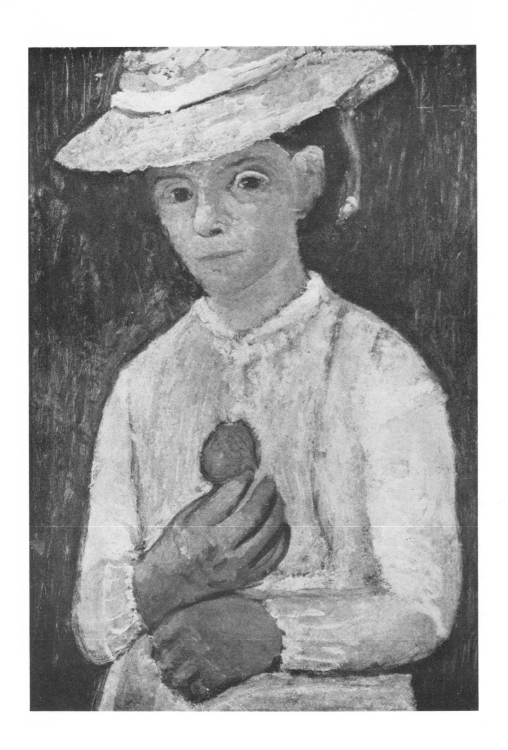

61 MODERSOHN-BECKER
 SELF PORTRAIT IN A STRAW HAT (*about* 1905). *Oil on canvas, 25½ x 18 inches*
 Collection the Folkwang Museum, Essen

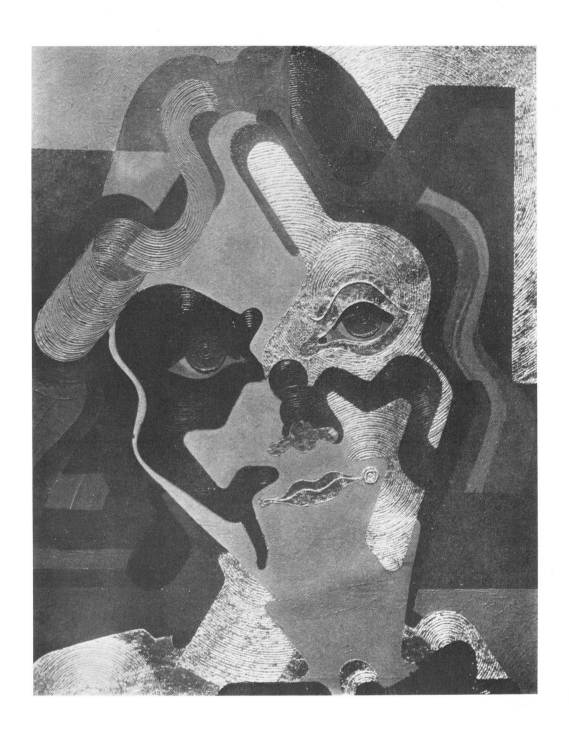

MOLZAHN 64

BEATRICE III (1930). *Oil on canvas, 35½ x 44½ inches*
Collection the Artist, Breslau

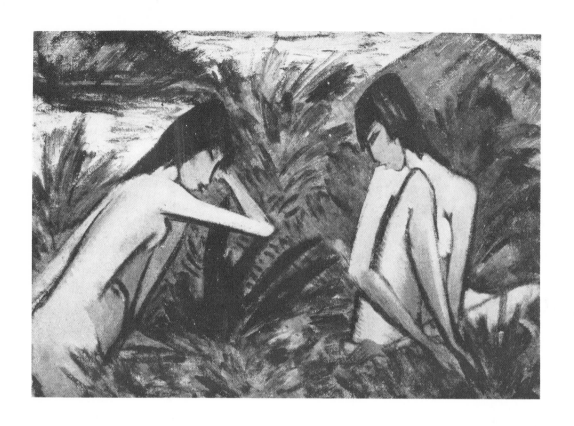

65 MUELLER
GIRLS BATHING (1921). *Oil on canvas, 37 x 31 inches*
Collection Dr. W. R. Valentiner, Detroit

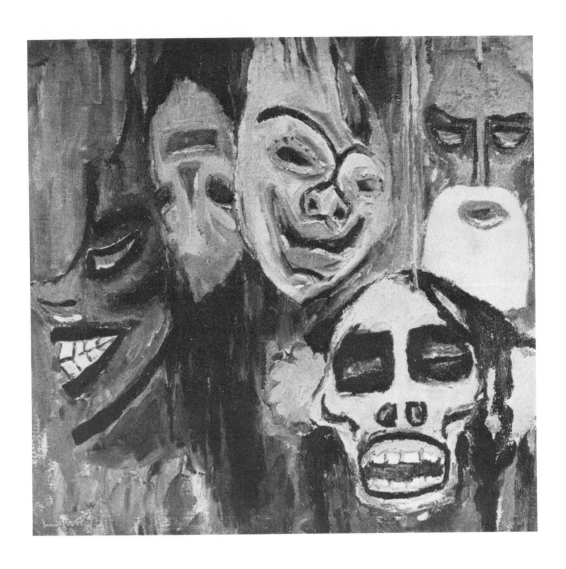

NOLDE 68

MASKS (1911) *Oil on canvas, 28½ x 30⅛ inches*
Collection the Folkwang Museum, Essen

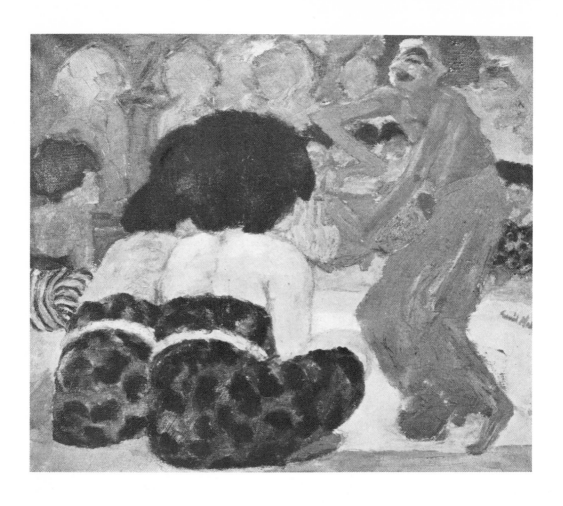

70 NOLDE

INDIAN DANCERS (1915). *Oil on canvas, 34 x 40 inches*
Collection Dr. W. R. Valentiner, Detroit

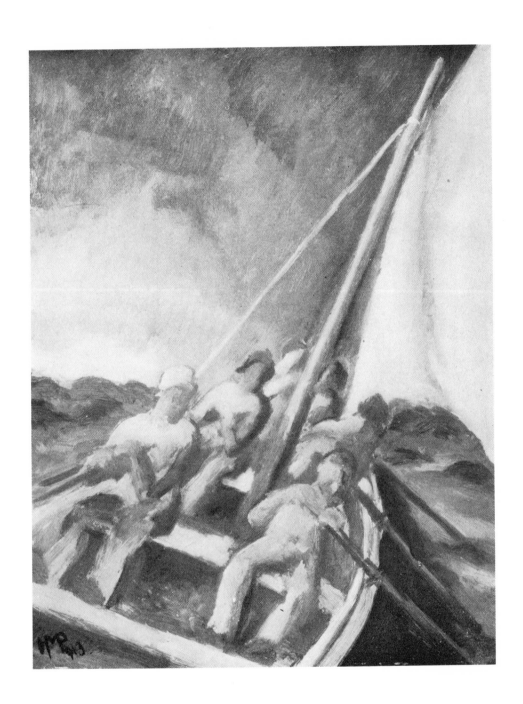

PECHSTEIN 74

Life Boat (1913). *Oil on canvas, 17¾ x 14⅝ inches*
Collection the National Gallery, Berlin

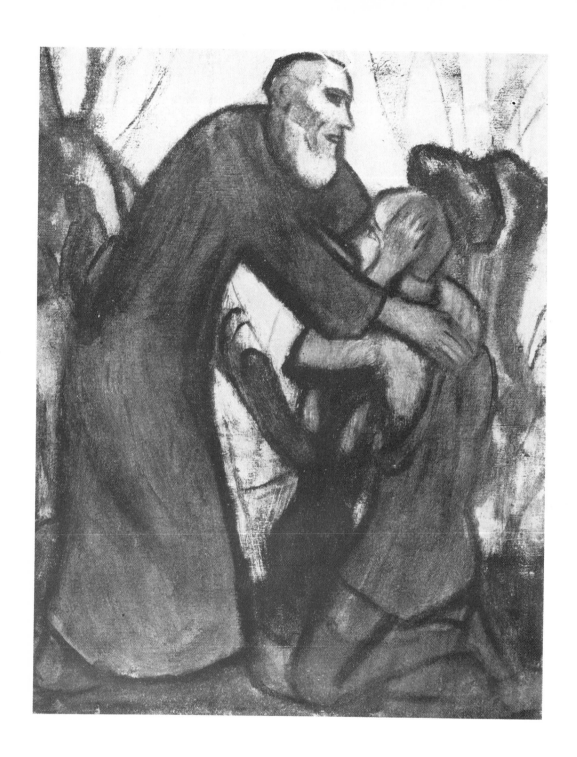

79 ROHLFS

Prodigal Son (*about* 1922). *Oil on canvas,* 39⅜ x 31½ *inches*
Collection the Folkwang Museum, Essen

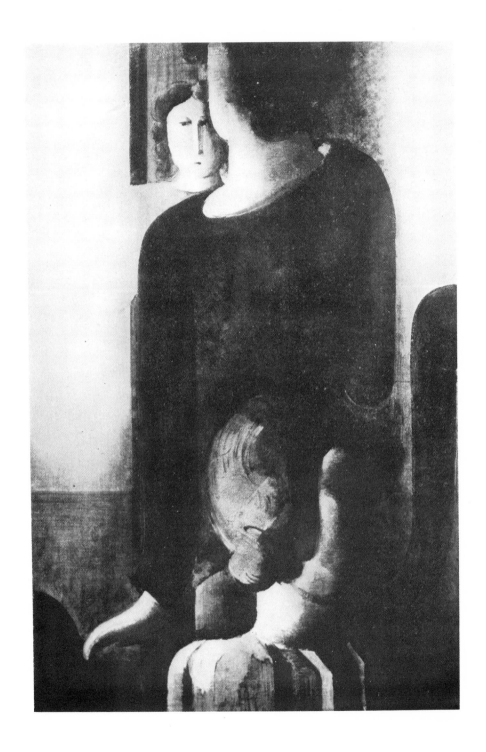

SCHLEMMER 80
THREE WOMEN (1928)
Collection Flechtheim Gallery, Berlin

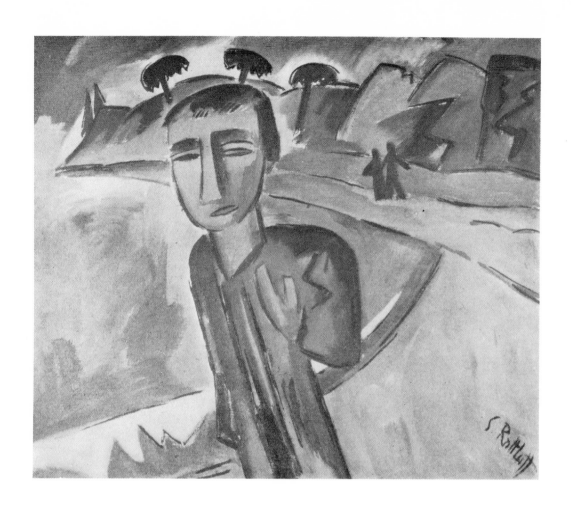

82 SCHMIDT-ROTTLUFF

Evening on the Sea (1920). *Oil, 34 x 40 inches*

Collection Dr. W. R. Valentiner, Detroit

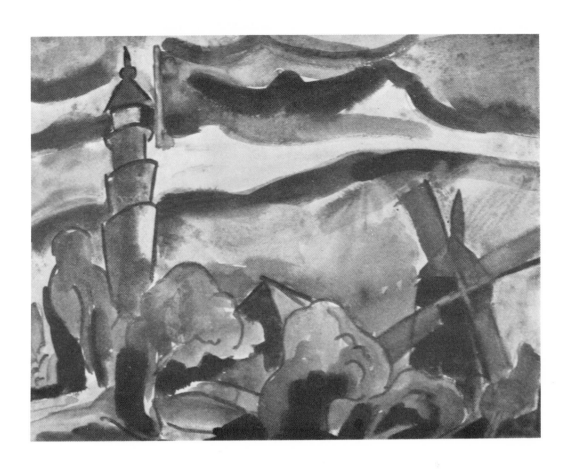

SCHMIDT·ROTTLUFF 86

THE BLUE TOWER (*about 1926*). *Watercolor, 18⅝ x 24 inches*
Private Collection, New York

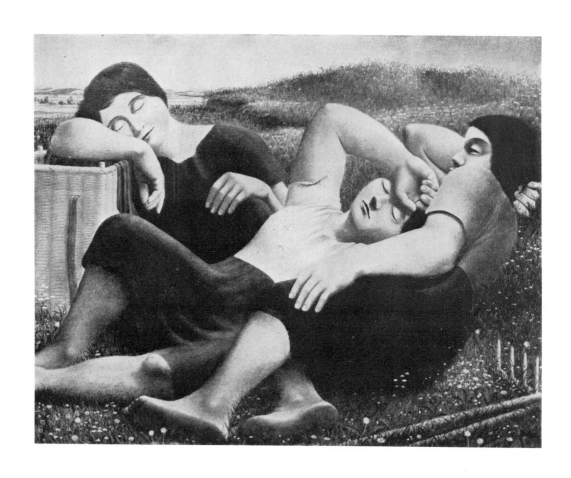

88 SCHRIMPF

SLEEPING GIRLS (1926). *Oil on canvas, 29½ x 37⅞ inches*
Collection the Municipal Museum, Munich

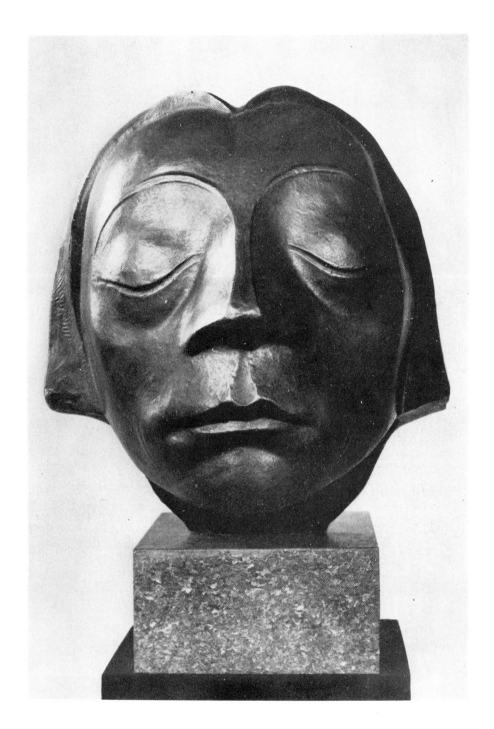

BARLACH 93

HEAD FROM THE WAR MONUMENT, GÜSTROW CATHEDRAL (1927)

Bronze, 14½ inches high

Collection E. M. M. Warburg, New York

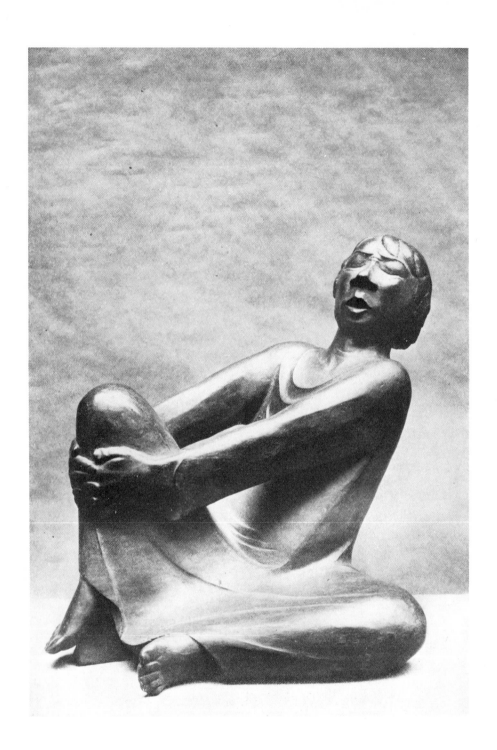

94 BARLACH
SINGING MAN (1928). *Bronze*
Collection Flechtheim Gallery, Berlin

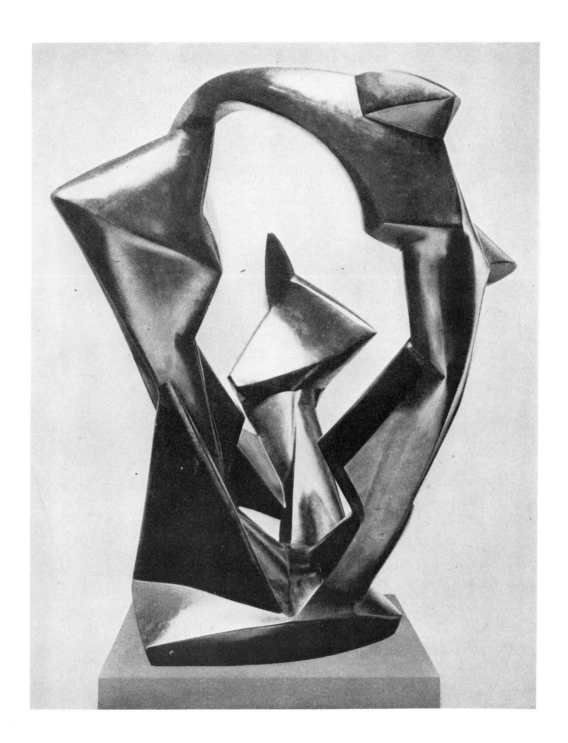

BELLING 95

TRIAD (1919). *Mahogany, 36 inches high*
Collection Flechtheim Gallery, Berlin

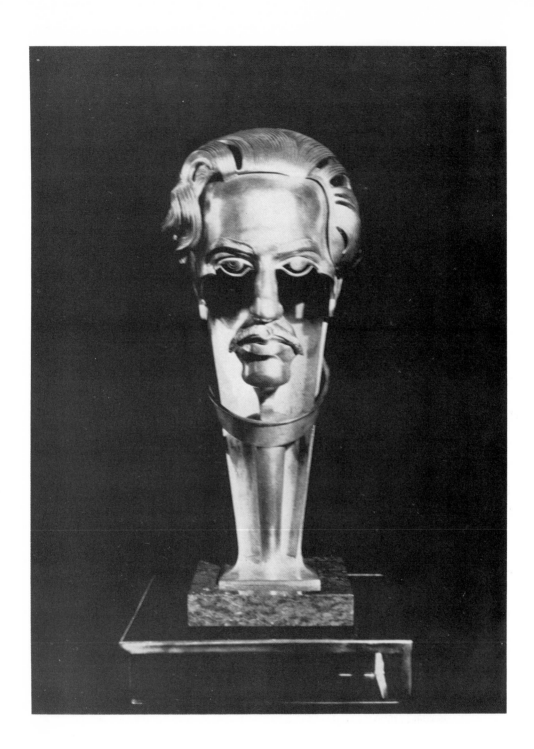

100 BELLING

PORTRAIT OF JOSEF VON STERNBERG (1930). *Silvered bronze, 21 inches high*
Collection Josef von Sternberg, Hollywood

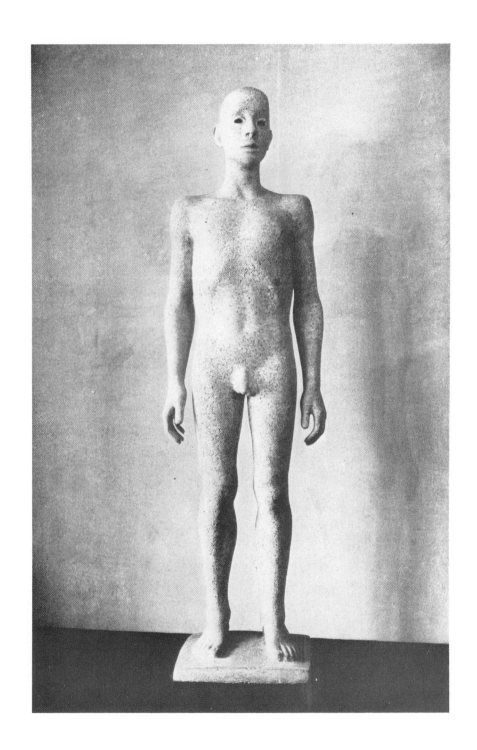

DE FIORI 101
SOLDIER (1918). *Artificial Stone, 52 inches high*
Private Collection Alfred Flechtheim, Berlin

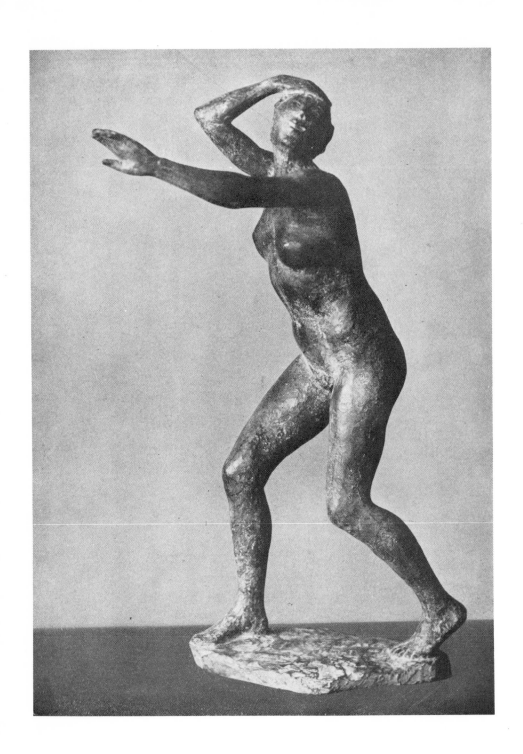

104 DE FIORI

FLEEING WOMAN (1927). *Bronze, 28⅜ inches high*
Collection Flechtheim Galleries, Berlin

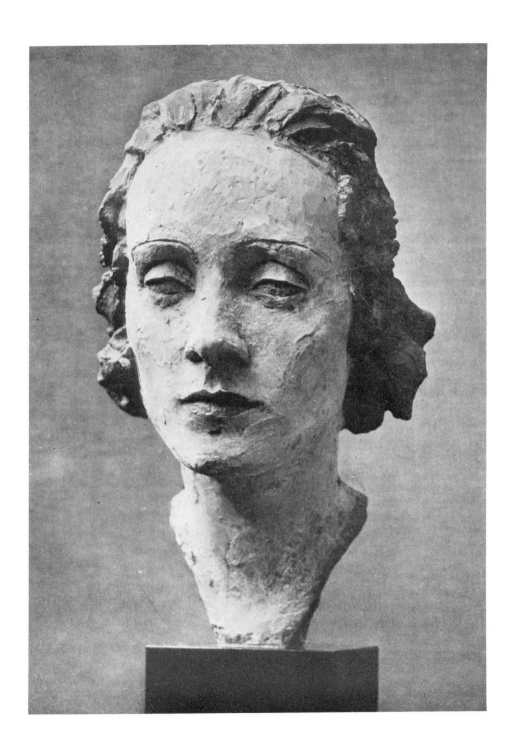

DE FIORI 105

MARLENE DIETRICH (1931). *Plaster with some color, 15 inches high*
Collection the Artist, courtesy Flechtheim Gallery, Berlin

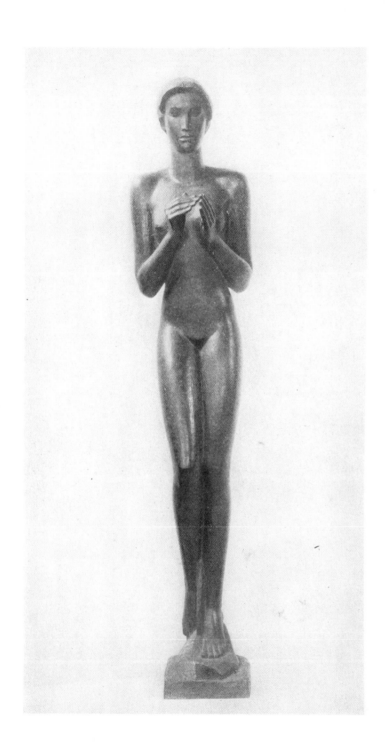

108 KOLBE

ASSUNTA (1921). *Bronze, 75 inches high*
Collection the Detroit Institute of Arts, Detroit

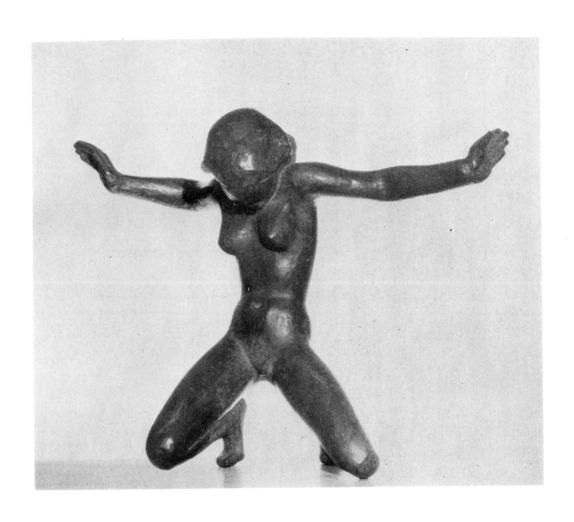

KOLBE **109**

GRIEF (1921). *Bronze, 15¾ inches high*
Collection Mr. and Mrs. Erich Cohn, New York

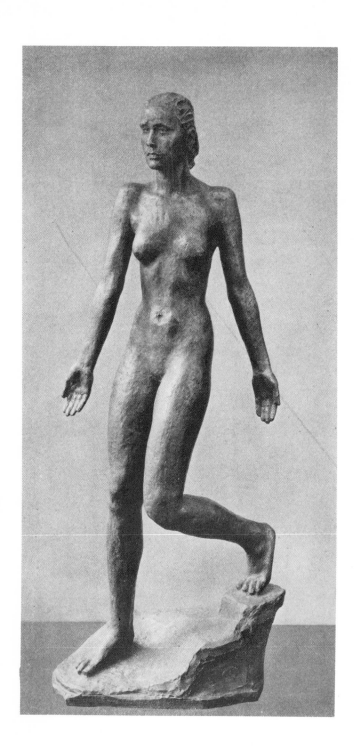

111 KOLBE

Woman, Descending (*about* 1927). *Bronze, 28⅜ inches high*
Collection Weyhe Gallery, New York

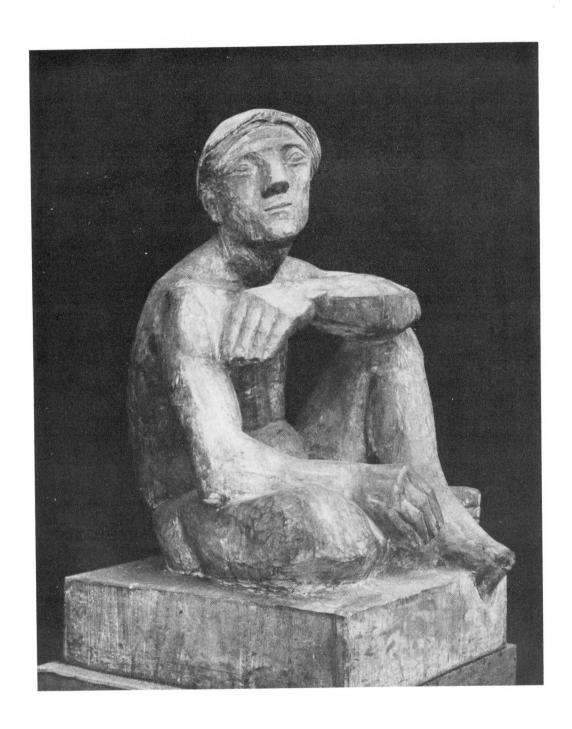

MARCKS 115
ADAM (1924-25). *Wood*
Collection the Artist

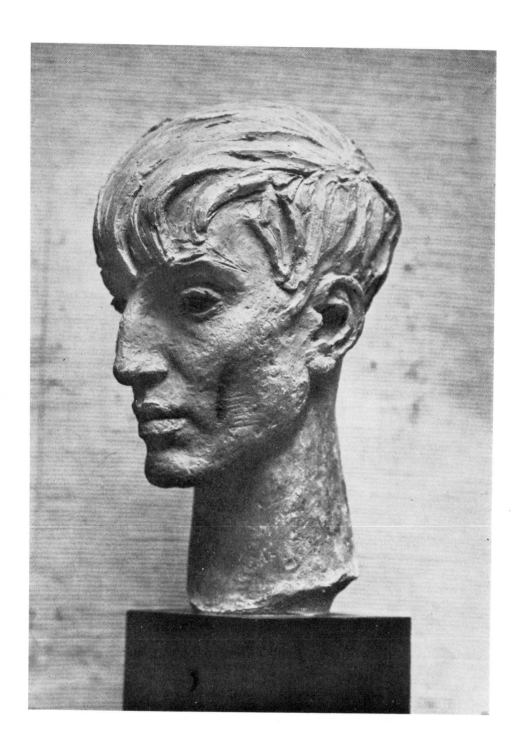

120 SINTENIS

Self Portrait (1926). *Terra cotta, 17 inches high*
Collection Weyhe Gallery, New York

Museum of Modern Art Publications in Reprint

Max Ernst. 1961. William S. Lieberman

Fantastic Art, Dada, Surrealism. 1947. Barr; Hugnet

Feininger-Hartley. 1944. Schardt, Barr, and Wheeler

The Film Index: A Bibliography (Vol. 1, The Film as Art). 1941.

Five American Sculptors: Alexander Calder; The Sculpture of John B. Flannagan; Gaston Lachaise; The Sculpture of Elie Nadelman; The Sculpture of Jacques Lipchitz. 1935-1954. Sweeney; Miller, Zigrosser; Kirstein; Hope

Five European Sculptors: Naum Gabo—Antoine Pevsner; Wilhelm Lehmbruck—Aristide Maillol; Henry Moore. 1930-1948. Read, Olson, Chanin; Abbott; Sweeney

Four American Painters: George Caleb Bingham; Winslow Homer, Albert P. Ryder, Thomas Eakins. 1930-1935. Rogers, Musick, Pope; Mather, Burroughs, Goodrich

German Art of the Twentieth Century. 1957. Haftmann, Hentzen and Lieberman; Ritchie

Vincent van Gogh: A Monograph; A Bibliography. 1935, 1942. Barr; Brooks

Arshile Gorky. 1962. William C. Seitz

Hans Hofmann. 1963. William C. Seitz

Indian Art of the United States. 1941. Douglas and d'Harnoncourt

Introductions to Modern Design: What is Modern Design?; What is Modern Interior Design? 1950-1953. Edgar Kaufmann, Jr.

Paul Klee: Three Exhibitions: 1930; 1941; 1949. 1945-1949. Barr; J. Feininger, L. Feininger, Sweeney, Miller; Soby

Latin American Architecture Since 1945. 1955. Henry-Russell Hitchcock

Lautrec-Redon. 1931. Jere Abbott

Machine Art. 1934. Philip Johnson

John Marin. 1936. McBride, Hartley and Benson

Masters of Popular Painting. 1938. Cahill, Gauthier, Miller, Cassou, et al.

Matisse: His Art and His Public. 1951. Alfred H. Barr, Jr.

Joan Miró. 1941. James Johnson Sweeney

Modern Architecture in England. 1937. Hitchcock and Bauer

Modern Architecture: International Exhibition. 1932. Hitchcock, Johnson, Mumford; Barr

Modern German Painting and Sculpture. 1931. Alfred H. Barr, Jr.

Modigliani: Paintings, Drawings, Sculpture. 1951. James Thrall Soby

Claude Monet: Seasons and Moments. 1960. William C. Seitz

Edvard Munch; A Selection of His Prints From American Collections. 1957. William S. Lieberman

The New American Painting; As Shown in Eight European Countries, 1958-1959. 1959. Alfred H. Barr, Jr.

New Horizons in American Art. 1936. Holger Cahill

New Images of Man. 1959. Selz; Tillich

Organic Design in Home Furnishings. 1941. Eliot F. Noyes

Picasso: Fifty Years of His Art. 1946. Alfred H. Barr, Jr.

Prehistoric Rock Pictures in Europe and Africa. 1937. Frobenius and Fox

Diego Rivera. 1931. Frances Flynn Paine

Romantic Painting in America. 1943. Soby and Miller

Medardo Rosso. 1963. Margaret Scolari Barr

Mark Rothko. 1961. Peter Selz

Georges Roualt: Paintings and Prints. 1947. James Thrall Soby

Henri Rousseau. 1946. Daniel Catton Rich

Sculpture of the Twentieth Century. 1952. Andrew Carnduff Ritchie

Soutine. 1950. Monroe Wheeler

Yves Tanguy. 1955. James Thrall Soby

Tchelitchew: Paintings, Drawings. 1942. James Thrall Soby

Textiles and Ornaments of India. 1956. Jayakar and Irwin; Wheeler

Three American Modernist Painters: Max Weber; Maurice Sterne; Stuart Davis. 1930-1945. Barr; Kallen; Sweeney

Three American Romantic Painters: Charles Burchfield: Early Watercolors; Florine Stettheimer; Franklin C. Watkins. 1930-1950. Barr; McBride; Ritchie

Three Painters of America: Charles Demuth; Charles Sheeler; Edward Hopper. 1933-1950. Ritchie; Williams; Barr and Burchfield

Twentieth-Century Italian Art. 1949. Soby and Barr

Twenty Centuries of Mexican Art. 1940

Edouard Vuillard. 1954. Andrew Carnduff Ritchie

The Bulletin of the Museum of Modern Art, 1933-1963. (7 vols.)

This reprinted edition was produced by the offset printing process. The text and plates were photographed separately from the original volume, and the plates rescreened. The paper and binding were selected to ensure the long life of this library grade edition.